WILDERNESS CANADA

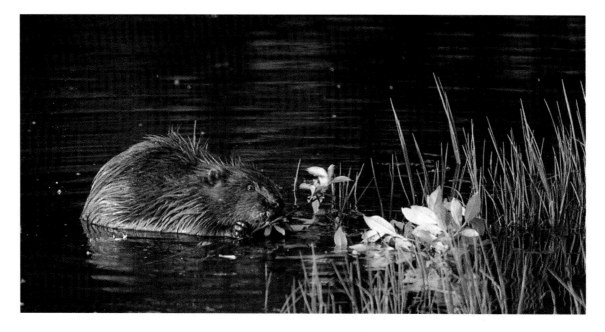

He knew how to take advantage of every cover, to crawl
on his belly like a snake, and like a snake, to leap and strike.
He could take a ptarmigan from its nest, kill a rabbit as it slept,
and snap in mid air the little chipmunks fleeing a second too late for the trees.
Fish, in open pools, were not too quick for him;
nor were beaver, mending their dams, too wary.
He killed to eat, not from wantonness;
but he preferred to eat what he killed himself.
So a lurking humor ran through his deeds,
and it was a delight to steal upon the squirrels,
and, when he all but had them, to let them go,
chattering in mortal fear to the treetops.

JACK LONDON
Call of the Wild

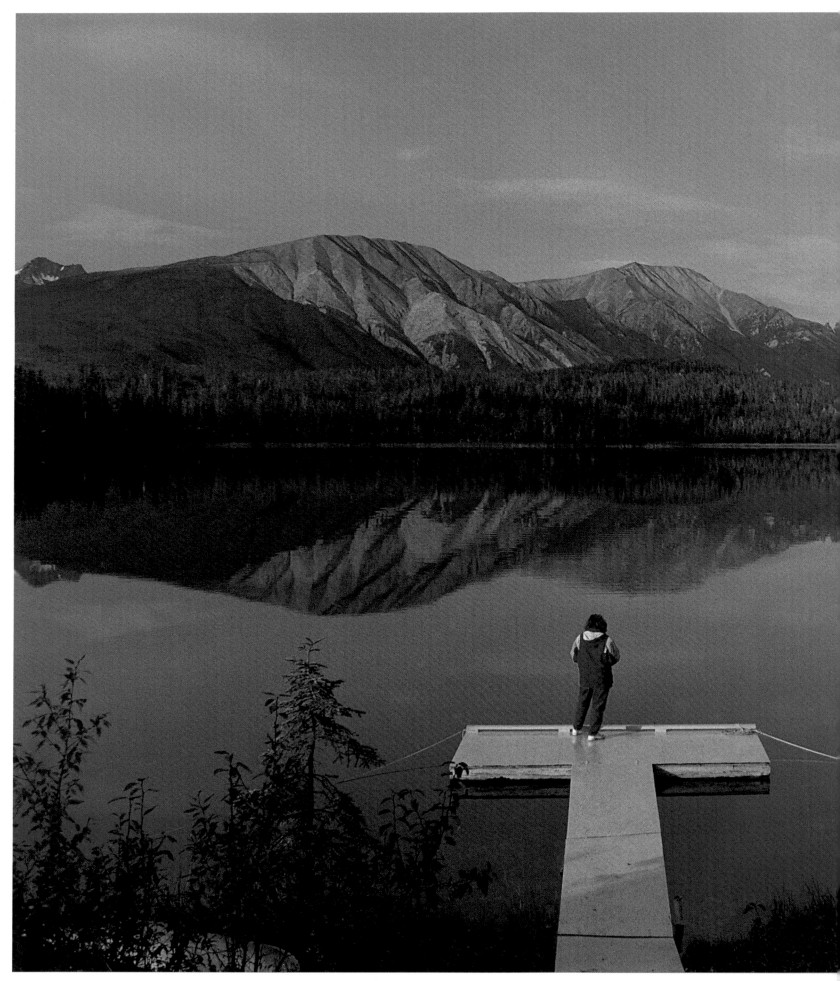

Tranquil nature in Nahanni National Park: grey cliffs and a deep green are reflected in the motionless waters of Rabbitkettle Lake.

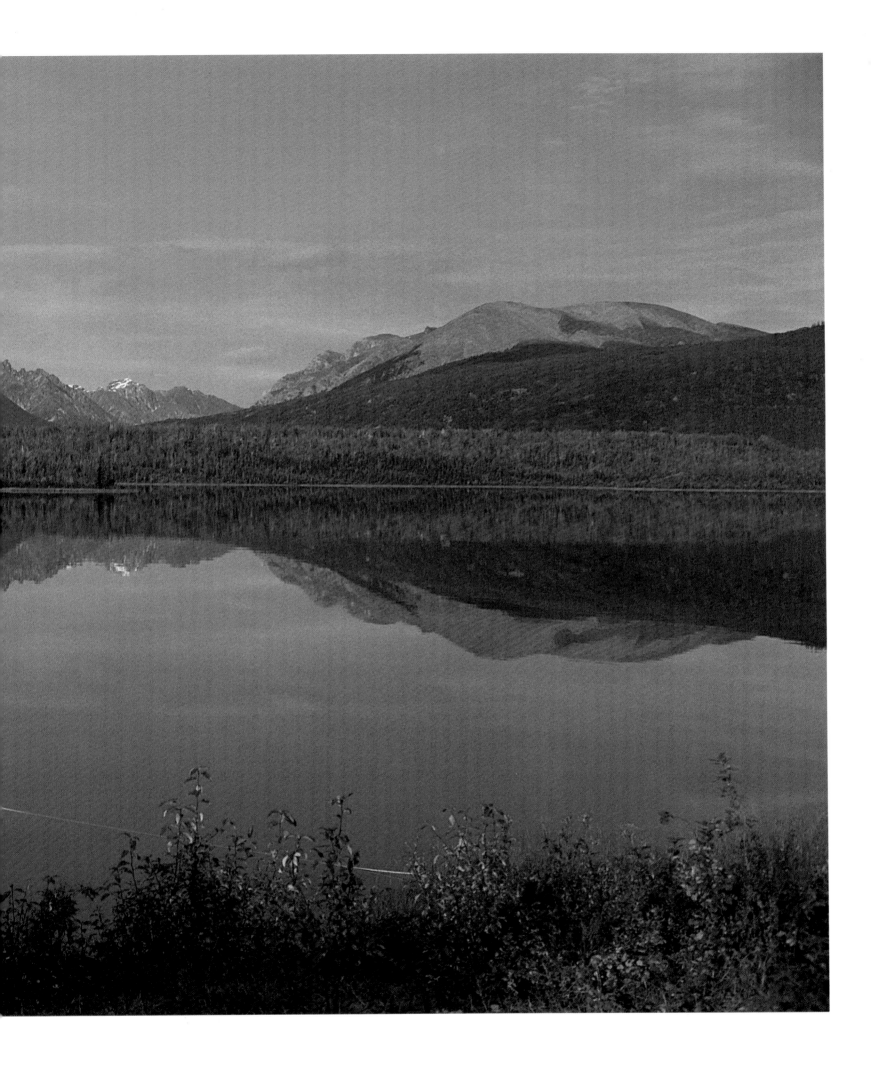

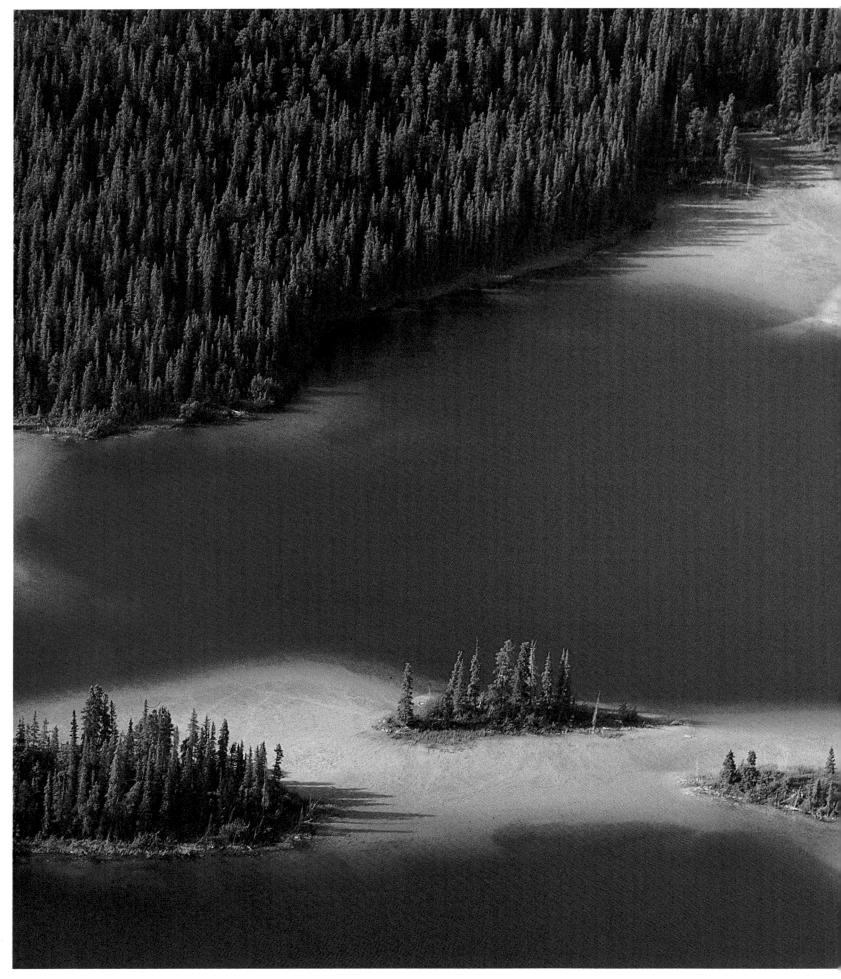

The volcanic ash subsoil reflects sunlight in the shallow parts, sinking a few meters farther on into the blue-black depths.

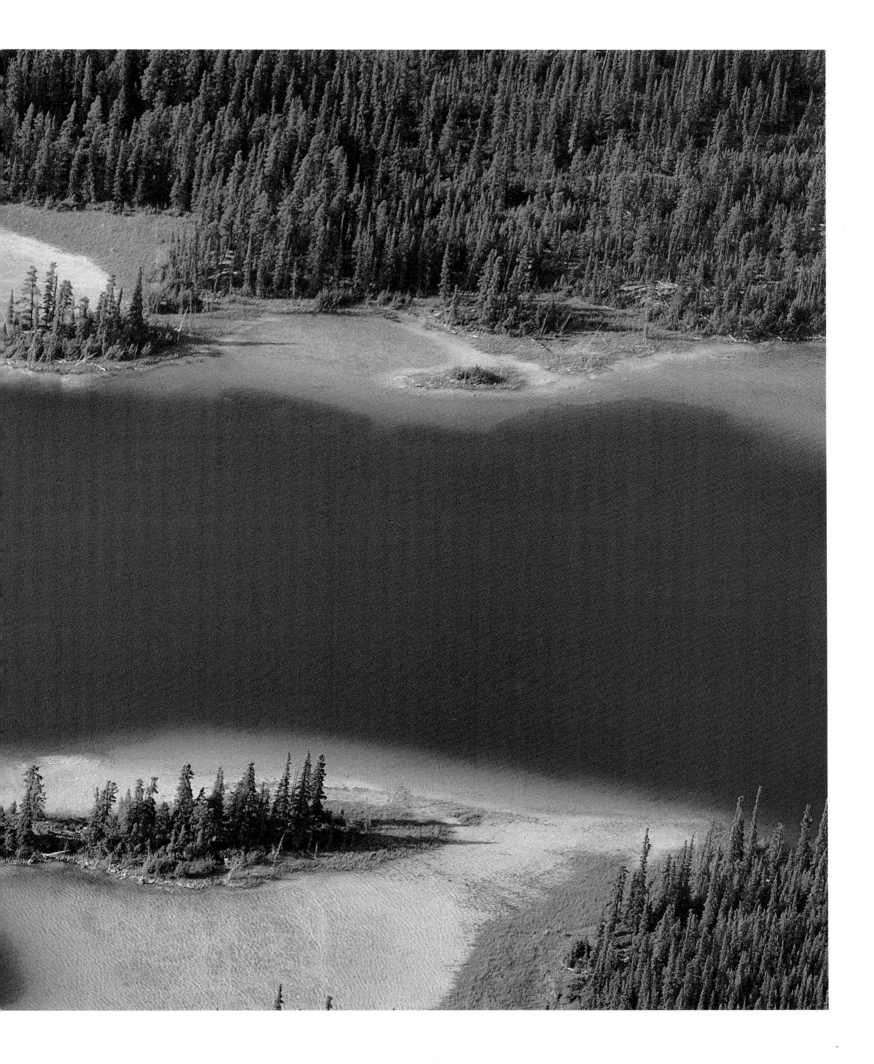

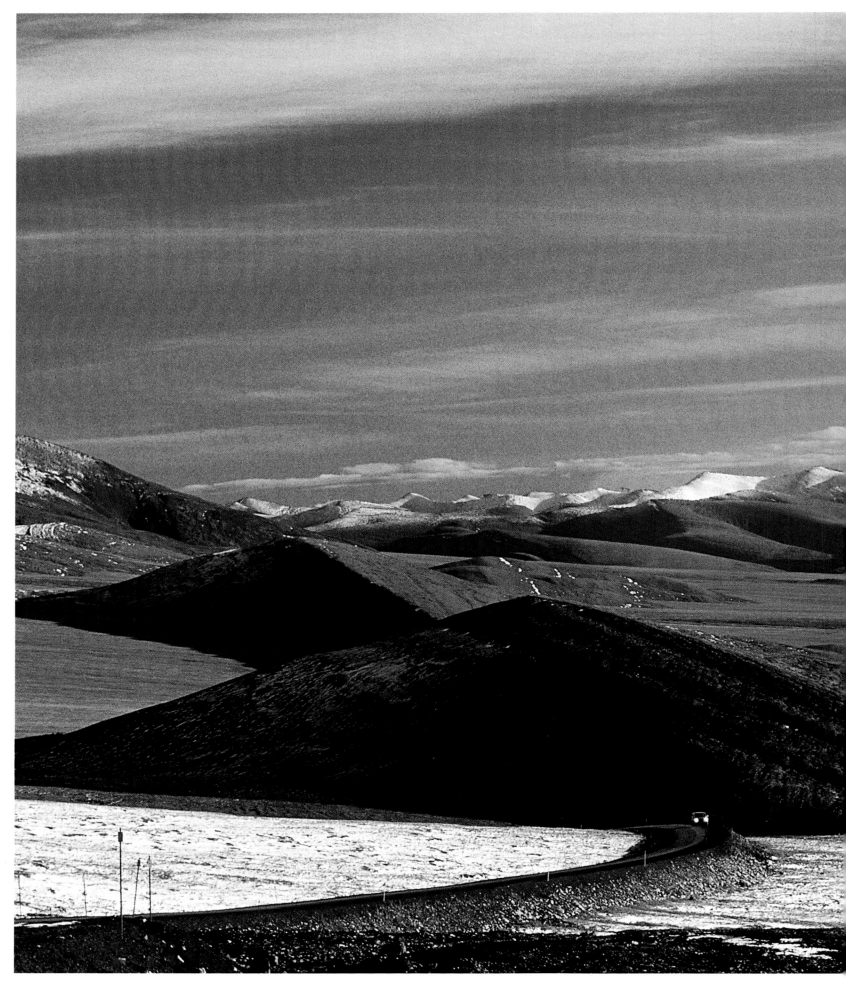

Dempster Highway disappears in endless tundra at the Arctic Circle, before rising to the snow-capped peaks of Richardson Mountains.

TRAVEL ADVENTURE
WILDERNESS CANADA

Photography by Wolfgang R. Weber
Text by Karl Teuschl

GRAPHIC ARTS CENTER PUBLISHING®

CONTENTS

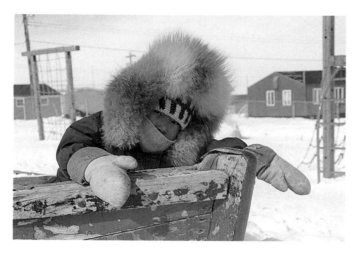

CANADA'S NORTH –
A LAND LIKE A CONTINENT
Karl Teuschl

Pingos and Permafrost 16

The Northwest Passage 20

People who Do Not Fear The Ice 25

Men Beyond Fear And Reproach 26

Awakening Stone to Life – Inuit Art 28

The Company of Adventurers 33

Survival at 40 Below –
Flora and Fauna of the North 37

The North in a State of Flux 42

Nature's Treasures: Canada's National Parks 47

Danger Threatens World's End 52

Gold in the Klondike! 54

Canada's North – Today and Tomorrow 56

Page 1: Beaver at his evening meal. – Left: Inuit child in furred parka.
Center: View over Nahanni National Park toward Nahanni Butte.
Right: Mountain goat in the northwest mountain region.

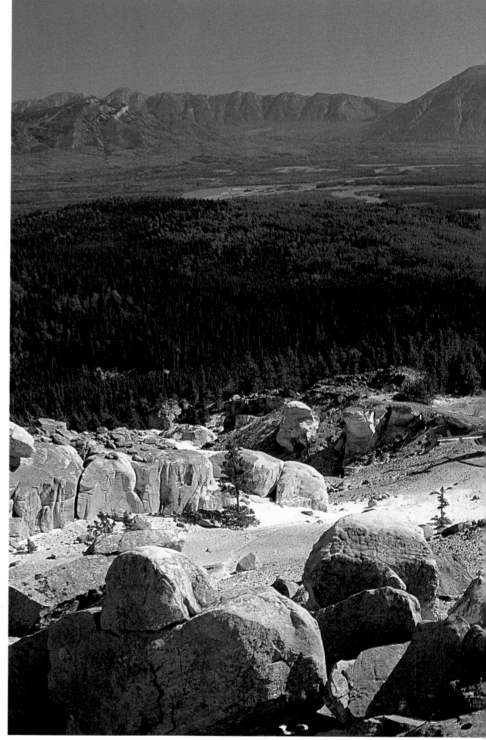

North of the sixtieth parallel the endless tundra lures,
interlaced with innumerable rivers and lakes,
majestic mountain massifs, impenetrable woods,
and permanent ice: "Wilderness Canada."

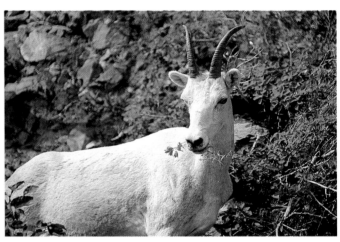

TRAVEL IN WILDERNESS CANADA 62
Karl Teuschl

Data · Facts · Figures 62

Map 63

Information 65

Getting There · Entry into the Country 66

Traveling in the Arctic 66

Highways of the North 67

Climate 68

Travel Periods and Clothing · Health Care 69

Accommodation · Northern Cuisine 70

Holidays and Festivals 70

Sporting Activities 71

Shopping and Souvenirs · Photographic Tips 72

Glossary of the Fauna 72

Canada's Arctic Cold Storage Room –
the North Pole 73

Places, Landscapes and National Parks
Worth Seeing 76

In Auyuittuq National Park 77

Index by Key Words 87

Text and Photo Credits · Imprint 88

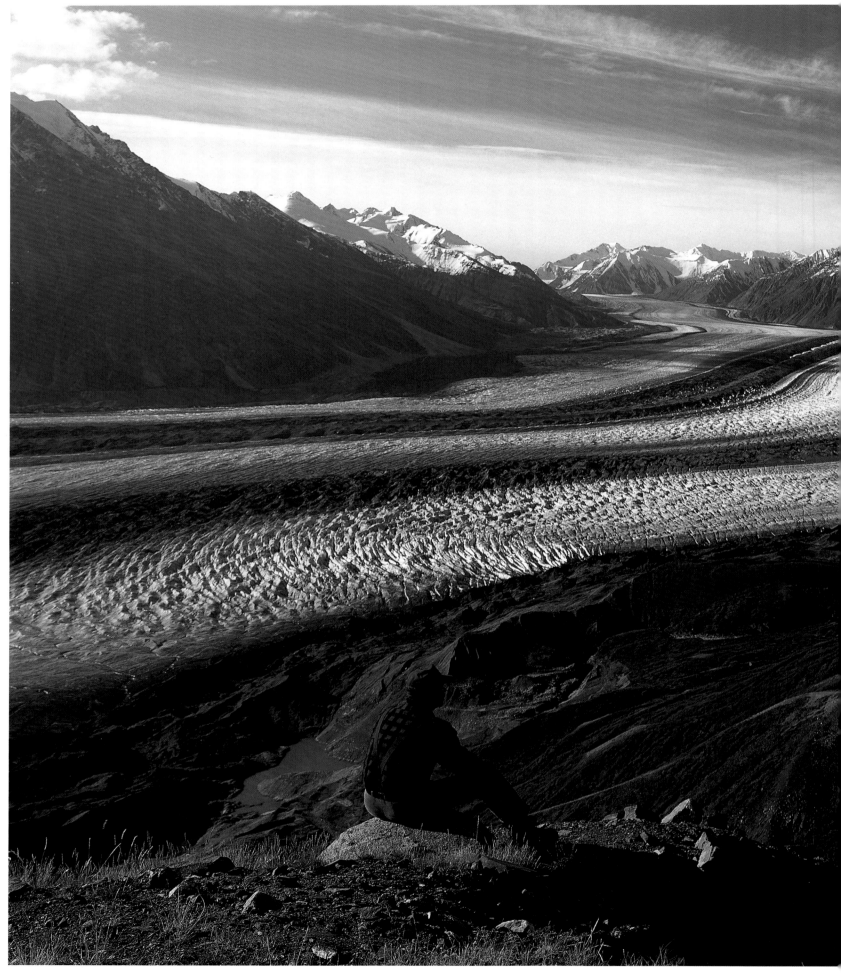

Kaskawulsh Glacier in Kluane National Park is sliding through the glacial valleys of the St. Elias Mountains down towards the Yukon.

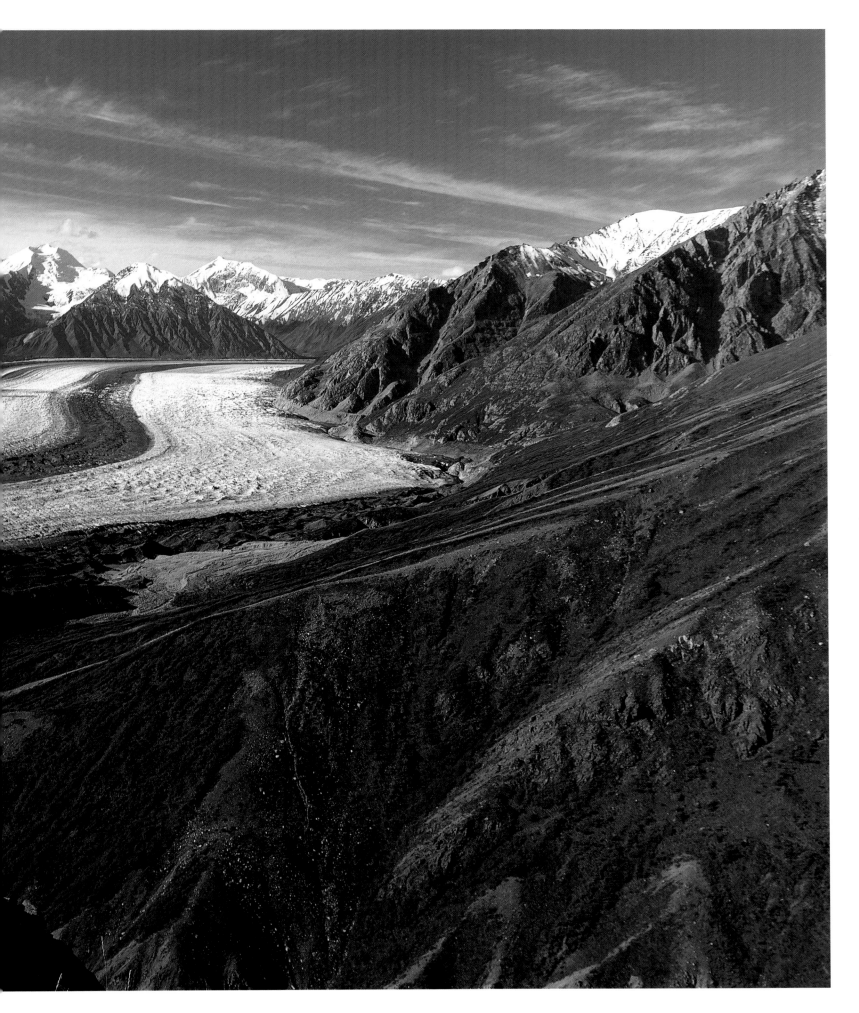

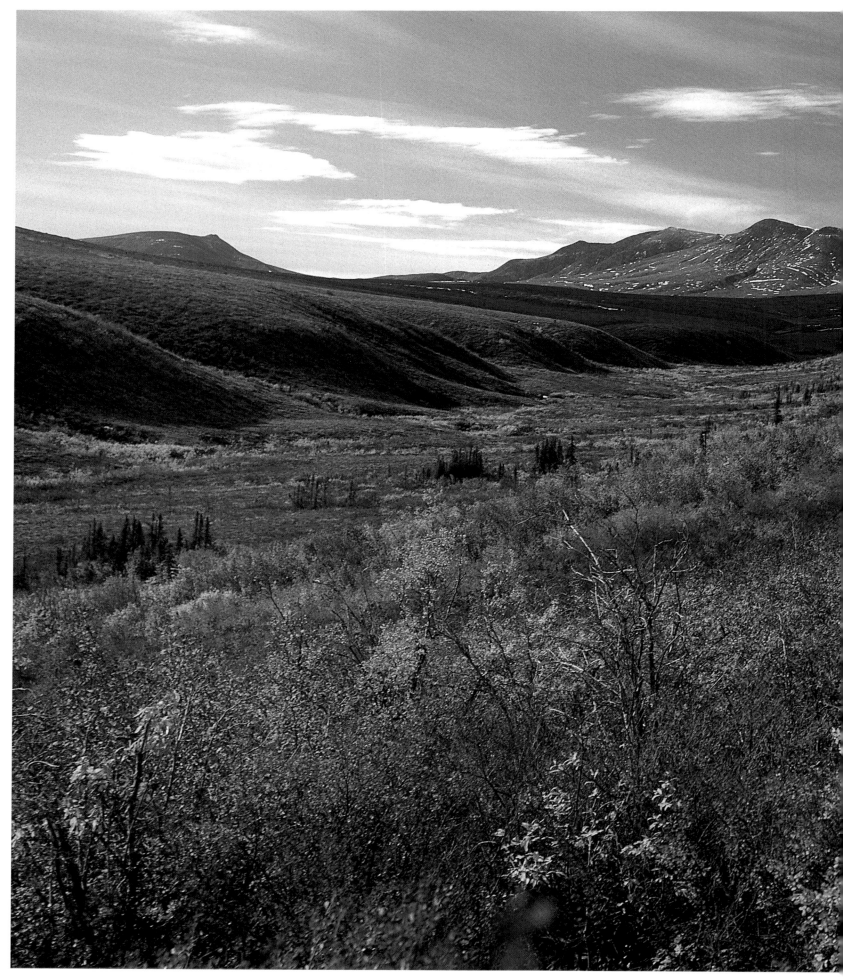

The tundra of Peel Plateau takes its leave of the short summer in a riot of color.

CANADA'S NORTH –
A LAND LIKE A CONTINENT

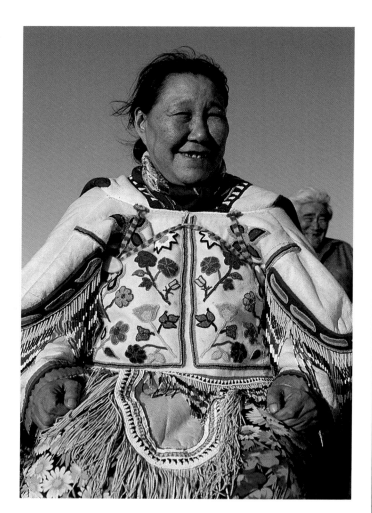

How can anyone tolerate living here? If one looks only at the surface, it is indeed forbidding. In the middle of nowhere, with no connections to the outside world. Eight months of winter each year and only a very short summer, when the unwary are set upon by swarms of greedy mosquitoes. As an example, consider Paulatuk, an Inuit village on the western coast of the Arctic Ocean in the Northwest Territories: one small store, a church, a dozen little prefab houses – that's it. A few chained-up dogs lie lazily under the houses built on stilts. A couple of fur-muffled silhouettes move along the street, wave at a snowmobile slowly rattling by. The main event in the village is the twice weekly arrival of the mail plane. But its very isolation is its attraction. The actual life of the village extends far beyond its main street. The Inuit people have a subsistence lifestyle that encompasses both the beauty and the bounty of hundreds of square miles.

The land immediately surrounding the village is completely flat. Not a tree, not a bush breaks the endless expanse. Far off, on the southeastern horizon, gently rolling hills arise. Even the banks of the wide bay on Amundsen Gulf are flat, dropping down only a few meters to the water. But that is only in summer, for in winter the area is locked in by pack ice, with ice floes piled up by ocean currents often towering over the houses. Isolation at World's End.

And Paulatuk is not even located at the World's End. By plane, it is only about a two-hour flight to Inuvik on the Mackenzie River, just 400 kilometers (250 miles) away. Inuvik, the largest city in the western Arctic, has a population of 3,000. The next settlement further east along the Arctic Ocean coast is Coppermine, more or less the same distance away. The round-trip by snowmobile instead of by airplane would take about four or five days over the trackless tundra. And this trip can only be accomplished in winter; in summer any trip by land would be almost impossible, for the permafrost, in spots frozen down to several hundred meters, thaws on the surface, turning much of the country into muskeg.

It is spring, the beginning of May, yet all around there is nothing but white. Endless white, the outlines of the eastern hills blurred, and the boundary between land and ocean indistinguishable. In a few weeks, the tundra will glow with a succulent green. Cotton-grass and Arctic poppies will bloom and the pack ice will recede to the north from the coast. Then, in summer, beluga whales will come, and great caribou herds will graze on the hills. Time for the hunt.

But not much later, at the beginning of September, autumn arrives; the tundra seemingly explodes in a riot of red and orange. The display only lasts for two or three weeks, before the world again becomes white and cold for eight months. And dark. From mid-

Arrayed for the feast: an Inuit woman from Arviat on the west bank of Hudson Bay in a festive outfit of embroidered and printed flowers. These ceremonial clothes are donned for numerous occasions.

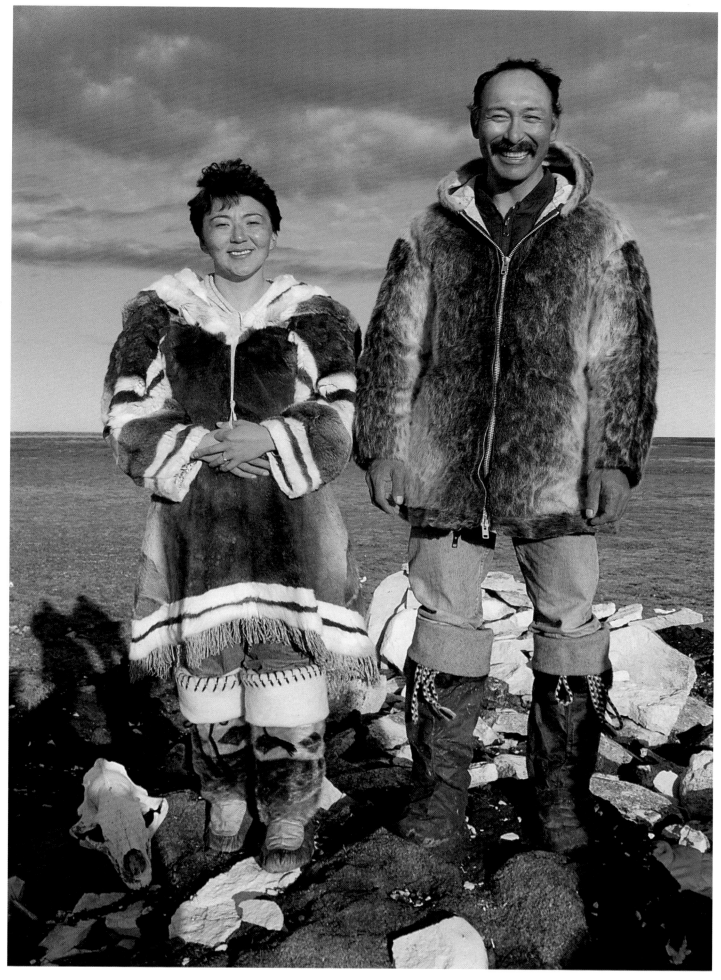

Warmly clad: Hannah and James from Coral Harbour on Southampton Island. She is wearing a caribou skin parka, he a seal jacket. The seal boots are lined with a thick felt inner sole.

15

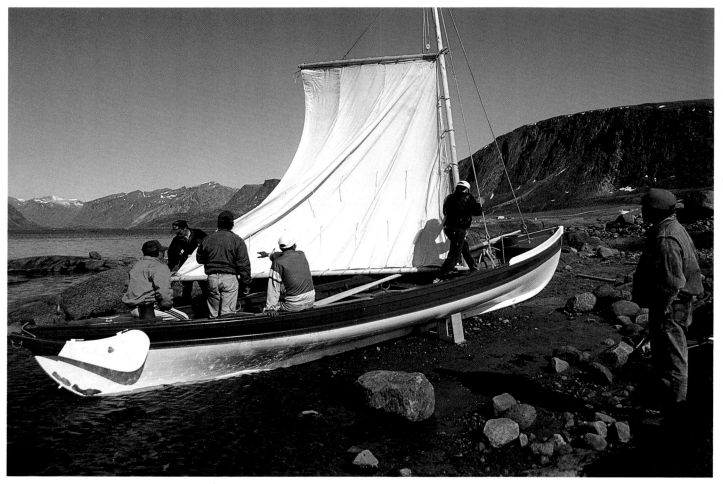

November to the end of January the sun never rises over the horizon. Only the ghostly Northern Lights darting across the sky will light the icy landscape. The Arctic night has cold so extreme that just taking a deep breath can freeze the lungs.

Paulatuk is a settlement like many others in the Arctic. Life is tranquil, flowing according to a fixed seasonal rhythm. The people here, almost exclusively Inuvialiut, an Inuit subgroup, adhere to their old traditions. The chase still plays an important role, as it did in the past. Some Inuit work as hunting and tourist guides. Trapping brings in an additional income, as do arts and crafts.

But people are not living in the past here: motor-boats and snowmobiles are the most important means of transportation. Telephones and televisions are found in every living room, bringing alive the colorful images of the south, such as wars on tropical islands and western heroes riding through cactus deserts. But that's about it for the blessings of modern civilization: there are no bars, no shopping malls, no cultural institutions. Rather, the entire extended family goes on berry-picking or fishing expeditions.

But how can anyone survive here? Every visitor to the Arctic asks this question at one time or another during the trip. It is possible to live here, but this raw, seemingly inimical land is not suitable for everyone. The Inuits have conquered it over the centuries, and have adapted to it. The few whites who have been lured here by higher salaries live for the most part in the larger villages. Nevertheless, most can only bear it for one season, some for a few years. Most eventually return south.

There are more white pioneers living in the Yukon Territory than in the Northwest Territories. Because in the Yukon there are woods, winter lasts "only" seven months, and most of the villages have roads that connect to the south. But even here, the Arctic wilds are authentically preserved, and many Yukoners would not want to live anywhere else. The north with its vastness and its tranquil, primeval wilderness is an addictive country.

PINGOS AND PERMAFROST

The visitor's first impression of the north is almost always of the overwhelming expanse. For hours one flies over plains carved by glaciers, myriads of lakes and never-ending grey-brown mountain ranges. Even though to the traveler on the Alaska Highway civiliza-

tion is seemingly still close, the wilderness nevertheless stretches endlessly on both sides of the road. From Watson Lake in the southern Yukon Territory, for example, it is more than one thousand kilometers (625 miles) north to the Arctic Ocean near Paulatuk – and on the way, there is not a road to be crossed. The next road further to the south is Yellowhead Highway, at a distance of some 600 kilometers (375 miles).

Approximately half of Canada's entire surface area is comprised in this wild northland, and remains largely undeveloped to this day. The Northwest Territories are, with their 3.4 million square kilometers (1.33 million square miles), about ten times bigger than Germany. From the 60th degree latitude, the southern boundary of the Territories, the land stretches 3,400 kilometers (2,125 miles) to the northern point of Ellesmere Island. From there, it is only 780 kilometers (490 miles) to the North Pole. The east-west expanse of northern Canada is similarly immense: from Cape Dyer on Baffin Island it is approximately 3,500 kilometers (2,187 miles) to Alaska's border at 141 degrees longitude.

It is difficult to comprehend that only some 90,000 people live in this extended region. Although Canada's north was mapped by plane in the 1950s, this did not mean that it was opened up. Man has only scratched at the edge of the wilds of this region, building tiny settlements here and there, which are lost in the vastness of the land. The decreasing population of only 0.02 people per square kilometer (0.05 per square mile) speaks for itself.

And yet the north is certainly not everywhere as flat and monotonous as Paulatuk. Indeed, it offers a variety of landscapes – but the dimensions are different from those in the south. It always takes hours of journeying either by plane or by car for the landscape to change. Gigantic plains lie extended, strewn with lakes, especially in the central parts of the north, in the Keewatin district west of Hudson Bay. This is where the Precambrian sedimentary rock of the Canadian Shield, in places over two billion years old, was ground away by the ice-age glaciers.

However, the thick glacial ice, which was up to one and a half kilometers (1.0 miles) thick during the last ice age, some 15,000 years ago, has long since melted. The old notion of the north as a single icy landscape is manifestly untrue. It is only along the mountains on the edge of the Canadian Shield that remains of ice caps can be found: the Penny Ice Cap in the mountains of Baffin Island, for example, or the glaciers in the up to 6,000-meter- (19,500-foot-) high Kluane Mountains in

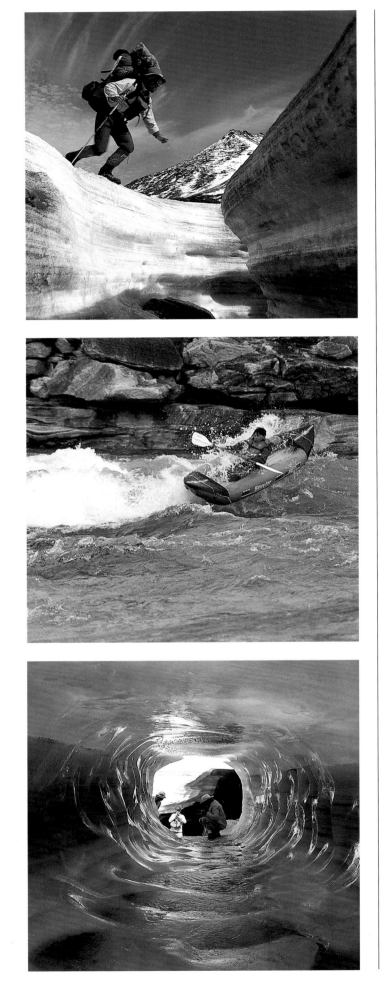

the southwestern corner of the Yukon Territory, and the glaciers found on the Arctic Islands in the far north.

However, ice distinguishes the landscape and life in a different way: during the centuries-long extreme cold, permafrost formed under the greater part of the northlands. This permanently frozen ground is found wherever the average yearly temperature is 0 degrees Celsius (32 degrees Fahrenheit) or lower. The groundwater level in the earth remains permanently frozen; even in summer, only the upper surface thaws. In the Yukon Territory particularly, which was not covered by protective glaciers during the ice age, the cold was effective over thousands of centuries in freezing the ground. In some regions, the permafrost descends thousands of meters. Arctic grasses and moss sometimes grow on topsoil only a few centimeters thick, and underneath is sheer ice over old lakes. Trees capable of thriving on permafrost can develop only very flat, shallow root systems – and are often indiscriminately blown over by the wind.

The various distortions of the earth can be seen especially well from a plane. Through a complicated play of summer thaw and refreezing, so-called polygon tundra (see page 43) is formed, especially in the Mackenzie district, where the topmost layer of earth splits into an interesting honeycomb pattern. On the Arctic Ocean coast near Tuktoyaktuk, up to one hundred-meter- (30-foot-) high pingos (Inuit expression, also called "ice volcanoes") can be seen, mountains with massive ice cores curving from the permafrosted ground – real "frost bumps" on the earth.

Man, too, was obliged to adapt himself and his architecture to these conditions. Because of the permafrost, most houses in the north are built on stilts, as they would otherwise sink into the quagmire during the summer months. For the same reason, roads such as the Dempster Highway were laid on insulating gravel.

The cold and the sparse vegetation in the north make life difficult for the fauna, each region supporting only a limited number of species. Caribou, the North American reindeer, must make extensive migrations to find enough food. Wolves, bears and other predators need large territories, and even then, sufficient food is not ensured. Special forms of adaptation have thus developed, with the purpose of ensuring survival (see also text insert on page 37). The female tundra grizzly, for example, does not implant the fertilized egg in her womb immediately after mating, but rather later in the year, in November, when the body is sure that there are enough fat stores available for the long winter pregnancy. Otherwise, the egg is not naturally expelled and never develops. Many species in marginal habitats practice this kind of natural selection.

Hiking through Auyuittuq National Park is a pleasure only for experienced trekkers: deep canyons of melted snow on Weasel River have to be crossed.

Treacherous rapids in Katanilik Provincial Park on Baffin Island, with high waves on the Soper River estuary in the lake of the same name, call forth the highest possible dexterity of the canoeist.

In the Arctic summer, melted glacial ice cuts through the meter-thick ice layers of Weasel River to the river bed, leaving behind huge ice tunnels.

Continued on page 25

Good physical condition, experience and a sense of balance are required for the tour through Auyuittuq National Park. Narrow wooden planks are the means to cross the foaming river. In the background towers the imposing peak of Mount Thor.

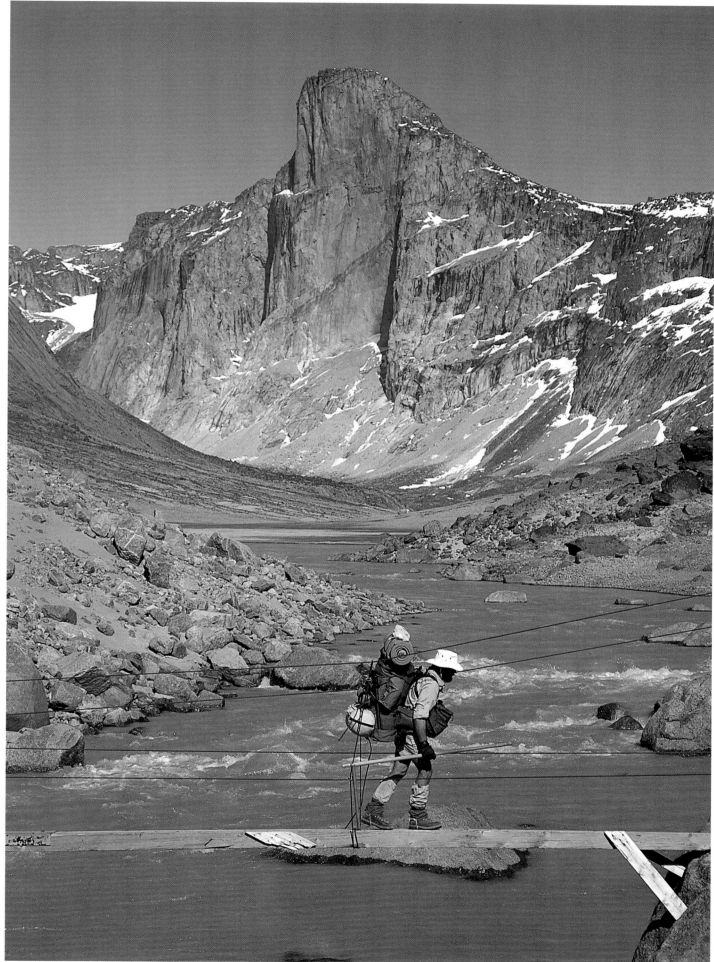

THE NORTHWEST PASSAGE

A tragic chapter in Canada's history of discovery

Since the sixteenth century, searching for the sea route along the icy northern coasts has inspired explorers of the western seafaring nations to put their lives on the line.

British historian Richard Hakluyt wrote as early as 1582 that there could be no doubt as to the existence of a short and direct passage to the west, indeed, even to Cathay. He remained unim-

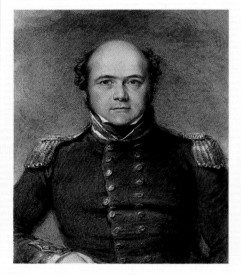

The British explorer Sir John Franklin (1786 to 1847) never returned from the perpetual ice.

pressed by the fact that his compatriot Humphrey Gilbert had vainly sought this passage in the previous decade. Hakluyt's reference to Cathay, China, explains why British navigators especially had so tenaciously pursued this quest for the Northwest Passage: Cathay was synonymous with the immense wealth of the Orient. The desire to partake of this immeasurable richness without passing through the Spanish-controlled parts of the world was behind the search for a sea route, a perilous search which would remain fruitless for three hundred long years.

No, fruitless is the wrong word, for during this quest, British seamen discovered Hudson Bay and thus a trading route leading deep into the Canadian interior and its wealth of furs. The consequence of this discovery was the creation of the Hudson's Bay Company. It was to form its own highly profitable empire and to some extent aid in the birth of what would become the wealthy British colony of Canada.

And yet, the search continued through the ice for the Northwest Passage. In 1576 and 1585, Martin Frobisher and John Davies reported water routes leading further west. William Baffin, an experienced Arctic captain, wrote in 1616: "... doubtless theare is a passage." In the year 1745, the English court in London offered the enormous sum, at the time, of 20,000 pounds to the discoverer of the passage.

It was not the money but rather the historical challenge which drove James Cook, the greatest of all British explorers, to the north. Cook was convinced of the existence of a way through the ice. After exploring the Newfoundland coast in 1763 – 1767, he wanted to tackle the Northwest Passage from the west during his third Pacific journey, and in 1778 he sailed into Cook Inlet in the Bering Strait. Massive pack ice, however, interrupted the Bering explorations. Cook thereupon decided to winter in Hawaii and to try again the next summer, but he was killed in Hawaii during this break.

The nineteenth century was almost two decades old when Edward Parry steered his ship into Melville Sound in 1819. He was on the right track, but ice barriers prevented him from realizing this. In 1845, a man who had already won much acclaim for his exploration of the Arctic set out to search for the Passage: Sir John Franklin, whom Sten Nadolny immortalized in his novel "Die Entdeckung der Langsamkeit" (The Discovery of Slowness). Franklin, having reached King William's Island with his two ships, had already mastered the most difficult part of the journey of discovery when he died there in 1847. His crew of more than one hundred men tried to escape by land – in vain, for they all died.

The British Admiralty and Lady Franklin organized the largest search party in history. The disappearance of the two ships remains a mystery, although individual finds have gradually fitted pieces into the puzzle. Even when all hope of saving the explorers was lost, the search continued for evidence of the Franklin Expedition. In 1984, scientists found three "preserved" corpses in the permafrost, the examination of which revealed that Franklin and his men had probably died of scurvy, a vitamin C deficiency, and lead food poisoning.

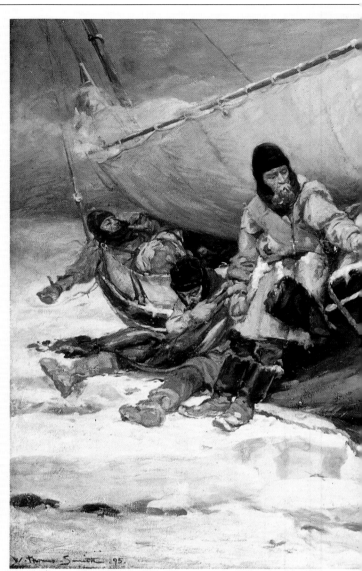

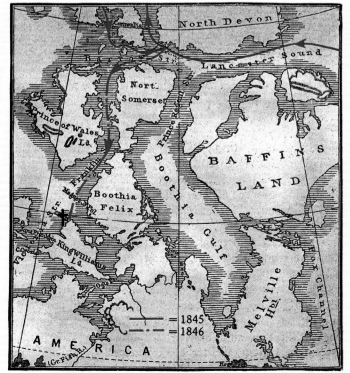

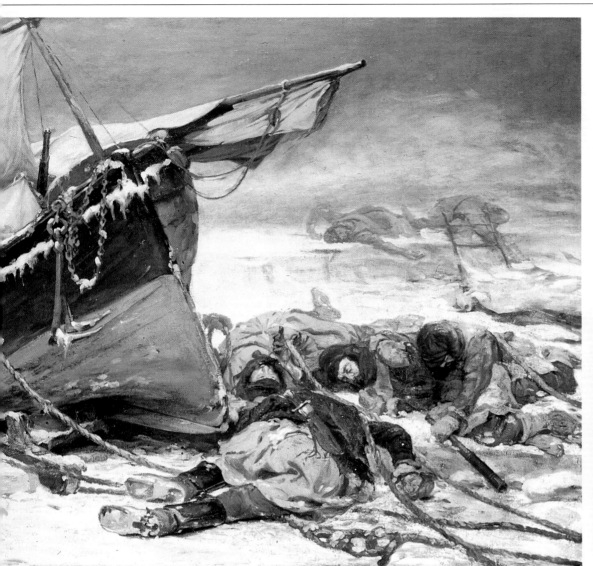

The search for Franklin extended the knowledge not only of the Arctic; it also led to the first crossing of the Northwest Passage. Robert McClure vanquished it in 1853–54 from the west to the east, partially traveling overland. It was Roald Amundsen of Norway who succeeded in crossing the entire Passage by ship between 1903 and 1906.

In 1942, the St. Roch, a Royal Canadian Mounted Police schooner, managed the first crossing of the Passage within one season, sailing from west to east, and later the Passage in the other direction. Today, the little ship is the gem of the Vancouver Maritime Museum collection.

In 1954, the Canadian ice-breaker Labrador proved that it was possible to plow a path through the ice, and in 1969 for the

The northern ice was responsible for the fate of Roald Amundsen as well: 1928, off Spitzbergen.

first time a real trading ship, the American oil tanker Manhattan, journeyed through the Passage to the oil fields of northern Alaska, with the help of a Canadian ice-breaker.

In the 1980s American ships navigated the Passage for the first time without Canadian accompaniment. This led to strife between the USA and Canada concerning sovereignty of the Northwest Passage: is it a Canadian inland waterway or an international channel? The question remains open – contrary to the Passage, which in the best of times opens only in July and August. Even cruise ships then try their luck – with no guarantee. The qualification is necessary, for several pleasure boats, faced with the ice edge, have had to turn back. One did manage it, however, in 1988: the trip lasted forty days, and passengers paid 20,000 dollars for it. *Klaus Viedebantt*

There was no escape for Franklin's crew either. This 1895 painting by W. Thomas Smith in London's National Maritime Museum evokes their fight for survival (top).

Franklin's 1845–46 route is marked on a map dating from that time (left).

The Norwegian Amundsen was the first to conquer the Northwest Passage in 1903–1906. In the picture right is Amundsen's ship "Maude", in which he set out on his expedition to the North Pole.

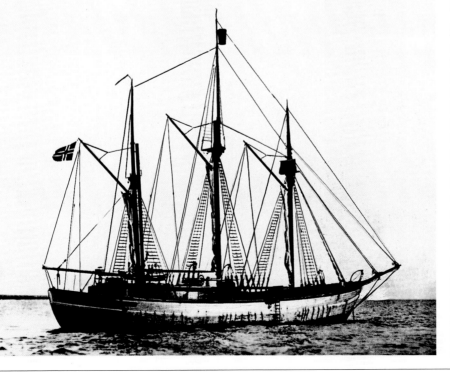

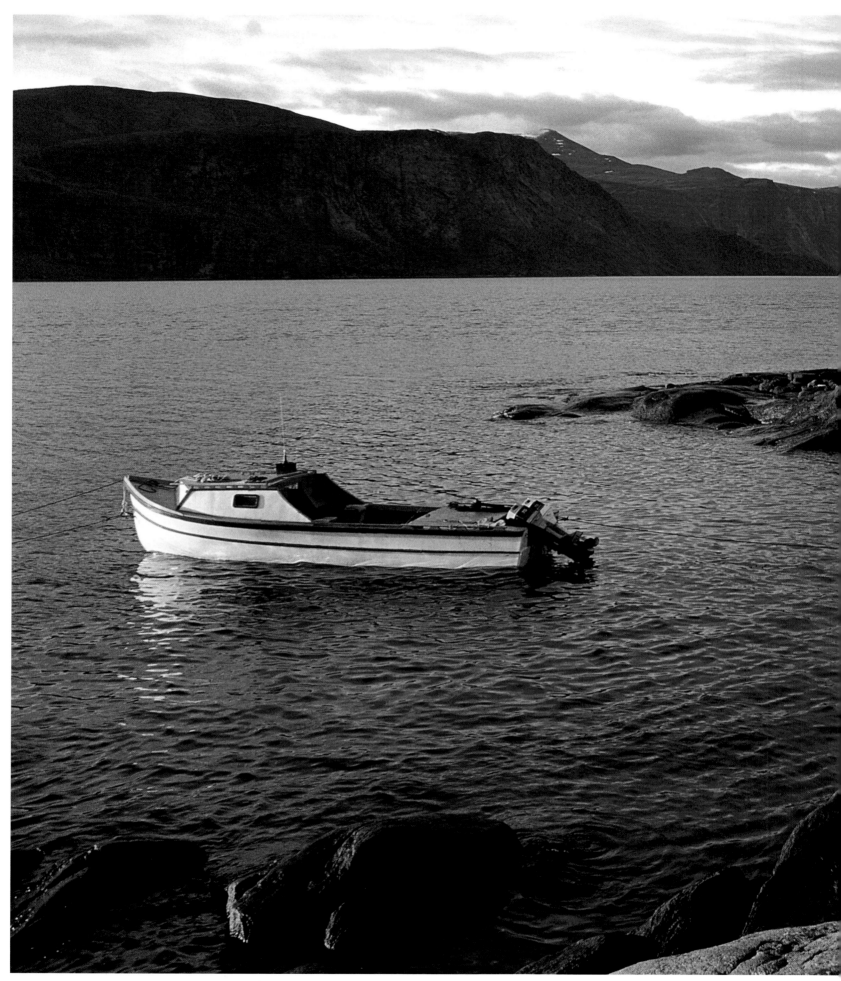

The plane goes on to Pangnirtung on Baffin Island and from there through the fjord to the primeval Arctic rocky landscape of Auyuittuq National Park.

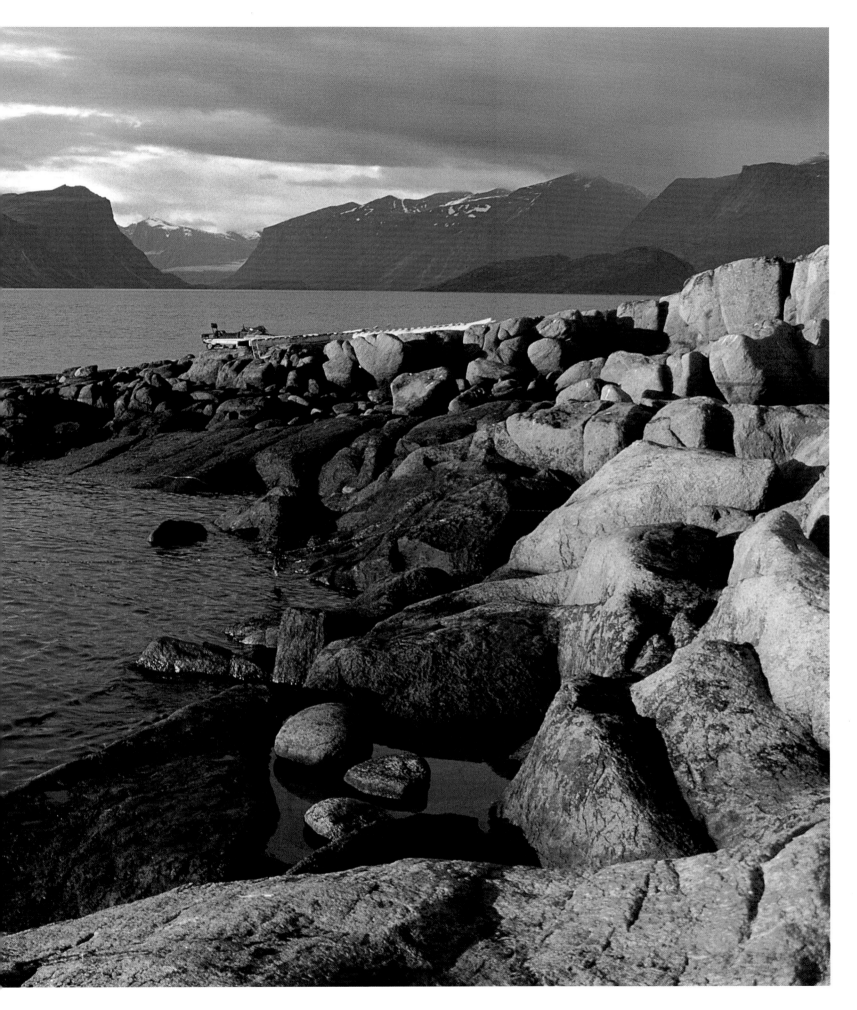

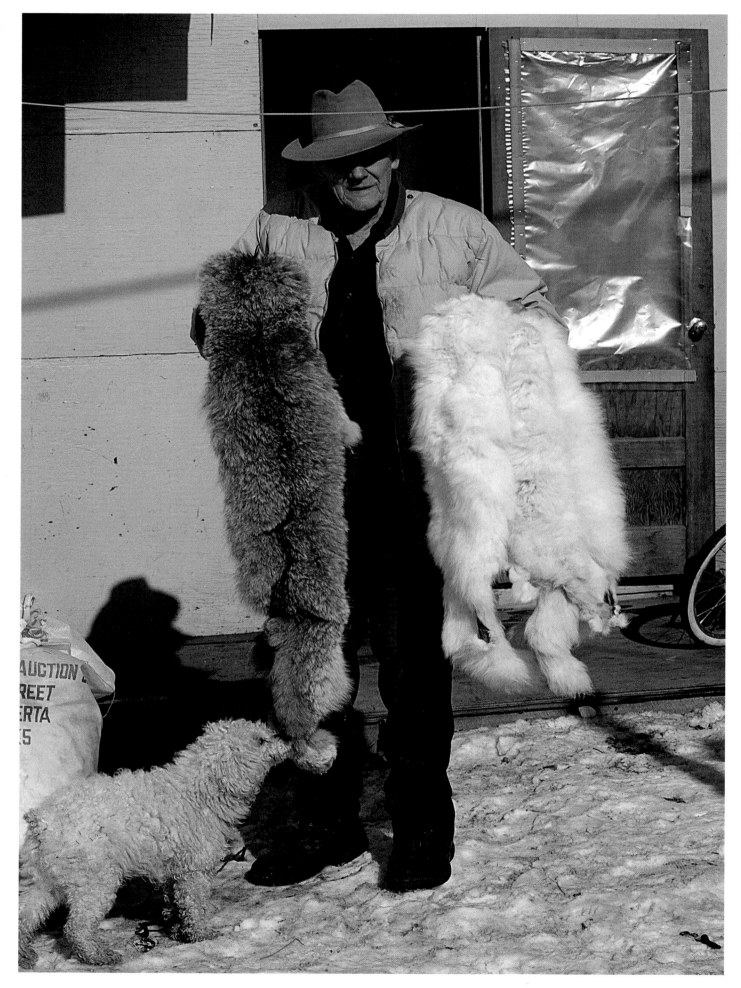

A sly fox on the tracks of the Hudson's Bay Company: veteran Slim Semmler still earns a good income as a fur trader in the western Arctic.

PEOPLE WHO DO NOT FEAR THE ICE

The name "Eskimo" has often eroneously been translated as "Raw Meat Eaters." The correct translation of the term is now considered to be "snowshoe netter." This name was given to the tribe living along the Arctic coasts in the north by the Dene living further to the south. Today, the descendants of the northern tribe prefer to use a term from their own language: Inuit, or "people;" in the singular, it is Inuk, meaning "person." In fact, this is now the official term used by the Canadian government for these people.

The ancestors of today's Inuit were probably the last wave of settlers from Asia to reach North America. It was only a few thousand years ago that within a few generations they spread from Alaska through all of northern Canada to Greenland – a migration over tremendous distances, which the Inuit accomplished in a masterly fashion in their umiaks, large boats made of walrus or sealskin stretched over wood or bone frames. The inhabitants of the Arctic still speak related dialects, and an inhabitant of Greenland can – albeit brokenly – communicate with an Inuk of northern Alaska.

Furs still ensure the survival of people in the north: Pijamini of Grise Fjord, the northernmost Inuit community in Canada, on the southern tip of Ellesmere Island.

But the Inuit were certainly not the first Asian people to discover America. At some point during the last ice age, perhaps within the last 40,000 years, northeastern Siberian hunter tribes followed herds of mammoths and other Pleistocene animals to Alaska. Due to the water trapped in the ice shelves, the famous land connection between the continents – now under water known as the Bering Strait – was at least partially exposed. Alaska and what is today the Yukon Territory were ice-free during this period, allowing these Paleo-Indians to live there. During the time between the two ice ages, they moved south through an ice corridor over the Yukon Valley and perhaps also by boat along the west coast, settling the American double continent.

The last original Indians to emigrate from Asia, probably some 12,000 to 15,000 years ago, were the ancestors of the Athapaskan-speaking Dene tribes, who still live in Alaska and Canada's north. Until modern times, these half-nomads roamed as hunters and fishers through the wooded regions on the southern edge of the tundra. Elk and caribou, whitefish and lake trout were their food sources, and they lived in little village communities scattered extensively over the north. Following the pattern of their ancestors, some of their tribes moved to the south, becoming the ancestors of the Apache and Navajo in the American southwest.

While the warmer wooded areas were therefore already peopled some 15,000 years earlier, the much more inhospitable Arctic zone in the far north was conquered much later. The earliest archeological finds – amazingly on Ellesmere Island in the extreme north – are dated as being from a period approximately 4,300 years ago. The descendants of these original Eskimo, who were of the Dorset culture, were already hunting walrus, muskoxen and caribou around 600 B. C. Their heyday lasted only to approximately A. D. 1000, for then the ancestors of today's Inuit, also known as the Thule-Inuit, pressed forward from the west and ousted or assimilated the Dorset tribes.

The Thule-Inuit, a people of highly-developed whale and seal hunters, had mastered the art of adapting to living conditions in the Arctic. They settled in the entire Arctic Ocean region as far as the northernmost islands of Ellesmere and northern Greenland –

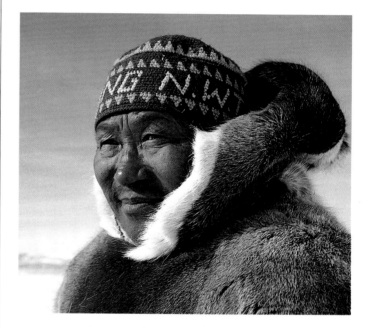

an area of a good two million square kilometers (780,000 square miles). No other hunter-gatherers had ever possessed such a gigantic tribal area. It was not until the Little Ice age, around A. D. 1650, when particularly harsh winters held the land in an icy grasp lasting for decades, that the Inuit had to abandon these settlements in the extreme north.

With the kayak (the closed, one- to three-man canoe of the hunter) and the umiak (an open cargo boat), the Inuit traveled far out to sea to hunt. Led by charismatic leaders, the Inuit lived in settlements of small tribal associations. The village shaman (angakok) carefully monitored the strict taboos regulating daily life and communicated while in a trance condition with the spirits of nature, entreating them to grant the tribe a good hunt. Even the language of the Inuit was tailored to the special living conditions in the Arctic north and had special and exact words for hunting and weather. Thus, there were over twenty expressions for the different forms of snow.

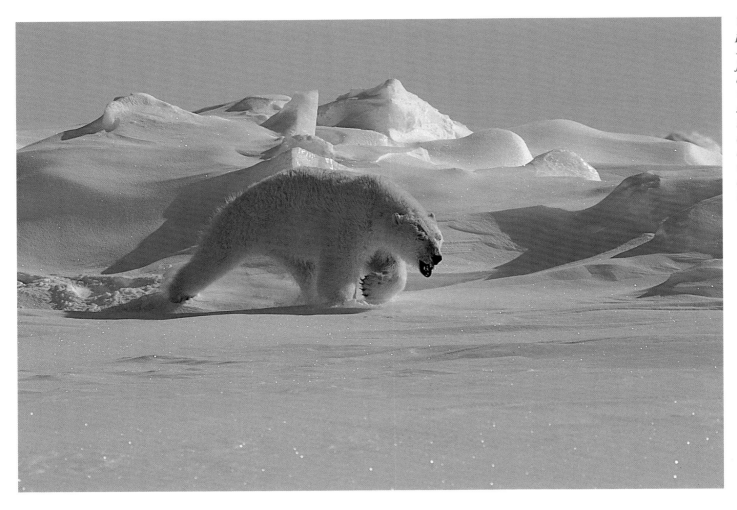

The king of the permanent ice in Barrow Strait fears neither enemy nor cold. With tremendous strength, a thick layer of fat and a dense pelt, this aggressive fellow is properly equipped for a life in the Arctic.

The perfect adaptation of the Inuit to the surroundings should not, of course, blind us to the fact that life in prehistoric times in the Arctic was often infinitely difficult and cruel. Countless hunters drifted into the void on ice floes; accidents with polar bears and crashing through the ice were all par for the course. When necessary, the weak elderly, who would be a burden to the family on the move, were abandoned in an isolated spot. Famine was the rule if there were no whales or if the caribou chose another route during their migrations. The statistical life expectancy was – not least owing to the high infant mortality rate – just sixteen years. Those reaching the age of thirty could count themselves lucky.

And yet, the Inuit were highly successful survivors. Within just a few centuries, they opened up one of the most inhospitable places on our earth to live and develop. What plants and animals managed only after a long evolution, these people managed in a short time with human intelligence. Their fur clothing has not been surpassed even today, their stone-age hunting tools could not be better.

The Inuit even developed a genetic change in the digestion of food. Their bodies are able to transform animal amino-acids into sugar much more efficiently than can the bodies of whites. Due to this fact alone, the Inuits could and can live almost exclusively on meat and fat. In the past, they never ate vegetables. The animals supplied their vitamin needs: fish oil is high in vitamins A (retinol) and D (calciferol); raw seal liver contains much vitamin C (ascorbic acid).

MEN BEYOND FEAR OR REPROACH

"I believe this is the land God gave Cain." The foregoing is the first recorded impression of a white discoverer of Canada's northeastern coast on the edge of the Arctic. Jacques Cartier, a Frenchman from St. Malo, was sailing along the coast of Labrador in the summer of 1534 when he wrote these words. A hasty judgment, certainly, for soon the French king possessed his own colony in this country, and the rich fishing grounds off Canada's coast were to guarantee that overseas fish was not missing from many a French table, thus encouraging the colony's development.

But Cartier was not the first European to set foot on North American soil. Almost forty years earlier, Giovanni Caboto, a Venetian in service to the English, sailed along Newfoundland's coast. And 500 years

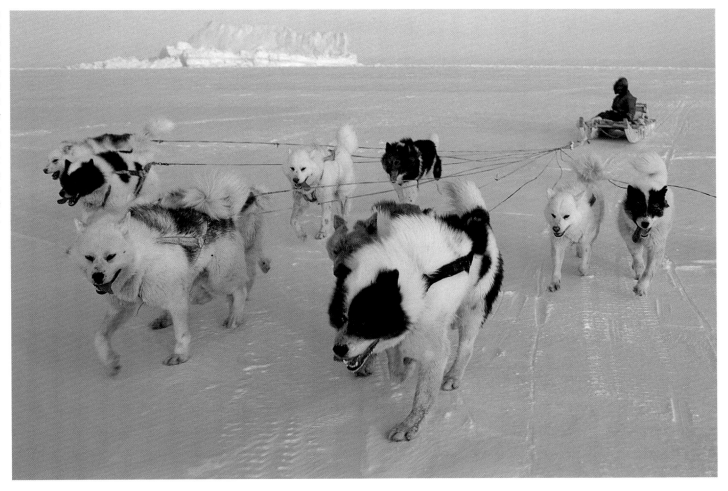

before that, Vikings from Greenland had reached America and had even founded a settlement. The Norsemen effusively called the newly discovered tract of land "Vinland," which means something like fertile, rich pasture land. And quite rightly, too, for at the time a much milder climate prevailed and the vegetation on the rocky island was more luxuriant than it is today.

According to recent archeological finds, the Vikings may have reached not just Newfoundland, but may even have forged into the far Arctic, for iron fittings from boats and parts of iron arms were found in 1978 on Ellesmere Island. However, these finds of unequivocally European origin could also have appeared in the region through trade with the Inuit.

The Vikings' settlement attempts were only of short duration. Vinland faded into oblivion, and it was Columbus who "discovered" America in 1492. Shortly thereafter, the European nations began to show lively interest in the north of the continent. The hope was to find gold and diamonds, treasures such as those brought back by the Spaniards from Central and South America. Imagination went even further: when the first ships returned from Canada's north with strange, twisted ivory horns, Europeans believed they had found the home of the unicorn. When further in-

vestigation revealed that these "horns" were the out-sized teeth of the narwhal, this only slightly curbed people's fascination with the north.

It was the search for the Northwest Passage, the legendary sea passage to India and China, which particularly provided the stimulus for the exploration of the Arctic Ocean (see also text insert on page 20). The English, in particular, sent numerous expeditions over the next centuries, seeking the way through the confusion of islands in the north, which were ice-free only during the few summer months. Fearless explorers sailed away for king and country, to increase the possessions and fame of the British Crown. Captains such as Martin Frobisher, Henry Hudson and Sir John Franklin gave their names to bays, mountain ranges and islands.

But their often years-long travels of discovery in the icy world frequently led to their destruction: their ships were crushed by pack ice, slit open by icebergs or blown off course by storms. Scurvy and other diseases claimed their victims. Many a ship lost its orientation in the ice fog, the dense fog which rises on the open water surfaces, even in summer.

It took some time before it was discovered that the magnetic North Pole lies directly between the Arctic

Continued on page 33

AWAKENING STONE TO LIFE

Inuit Art

Discovered quite late, Inuit art sculptures and engravings created with frugal means, trade high today on international art markets.

Seen from a distance, it lies like a small, dark lump in the showcase: a smooth, cold stone, of a greenish color, and only as big as a fist. But upon closer inspection, a few faint lines create contours, a few very fine engravings indicate feathers, with two large eyes above – and suddenly an owl emerges from the lifeless stone, peering with piercing gaze to the horizon. An adroit Inuit soapstone sculpture, brilliantly simple and yet full of dramatic life.

For thousands of years, the Inuit of northern Canada had created their arms and utility articles out of the natural materials at hand: stone and whale bones, horn and leather. For generations, they perfected the use of these few materials. Archeological excavations here have brought forth amulets and small carved figures from the Dorset Culture from the time around Christ's birth. The later Inuit of the Thule Culture used bone, antler, ivory and wood for decorated combs, harpoons and other articles of daily life. Soon after their first contacts with the whites, they began to make small sculptures and miniature tools for bartering purposes. However, it is only in the last fifty years that these forms of Inuit art have developed into a real art movement. Apart from the carvings of the northwest coastal Dene, this is the only independent Canadian art. It was influenced by the world of the whites only in the choice of tools.

Through an exposition and auction by the Canadian Guild of Crafts in Montreal in 1949, this Inuit art was made known to the public for the first time. In the 1950s, white artist James Houston settled in Cape Dorset, encouraging the Inuit to develop their talent and to work with new techniques. As a result of this, Cape Dorset graphic art prints became very much in demand.

Not least owing to the commercial success, other artist co-ops have since been established in many of these Arctic villages – and following the decline of the fur industry, the Inuits were in need of cash. In villages such as Holman, Cape Dorset and Baker

Top: Walrus hunter by Kellypalik Qimirpik, Cape Dorset.

Right: Figure of a bear by Inuk Manomie, Iqaluit.

Bottom: Caribou hunter by Luke Anowtalik, Eskimo Point.

Lake, art has even become the most important source of income. Inuit sculptures and prints can be found today in museums all over the world, and works by distinguished artists such as Pudlo Pudlat, Jessie Oolark and Pitseolak Ashoona fetch a good price.

Although a wide range of varying style movements has formed in the various regions and villages of the north, the materials used have, as a rule, remained the same. Soapstone and bone, whale teeth and baleen, walrus tusks and muskox horns are the most important. The motifs frequently have remained with the traditional: animals, birds, hunting and day-to-day scenes, fantastic mythological hermaphrodites, and people. But the influence of modern life can also be felt, and airplanes and ships are appearing in their art.

For generations, the life of the Inuit has been strongly visually oriented, and this orientation still influences their art. There exist iconographic and thematic relationships between the art forms, indicating a common ancestry. The eye was the most important sense organ. Children learned from their parents. Trained vision was a question of survival when hunting, as it was essential to recognize well-camouflaged animals quickly. Even shadowy outlines, a pair of eyes or a fin would betray to the Inuit what animal had been glimpsed. This minimalist point of view is found in their art. With only a few lines and a few central characteristics, dramatic movement and an impressive naturalness are conveyed to the exquisitely wrought sculptures, drawings on skin, and prints.

Karl Teuschl

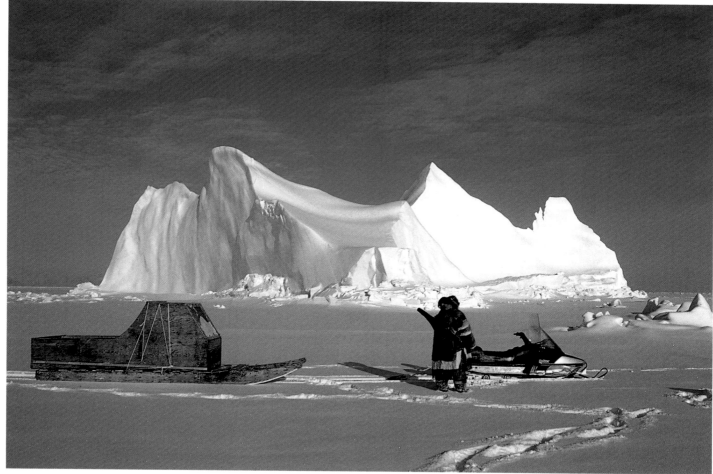

Under way with snowmobile and cargo sled on frozen South Cape Fjord on the southern end of Ellesmere Island.

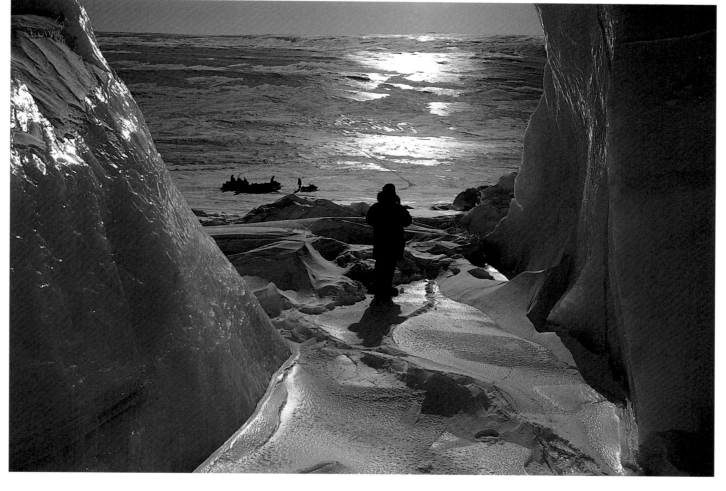

Arctic currents and blizzards cause ice fields to topple on one another, towering into meters-high ice ramparts, such as here in Wellington Channel between Devon and Cornwallis Islands.

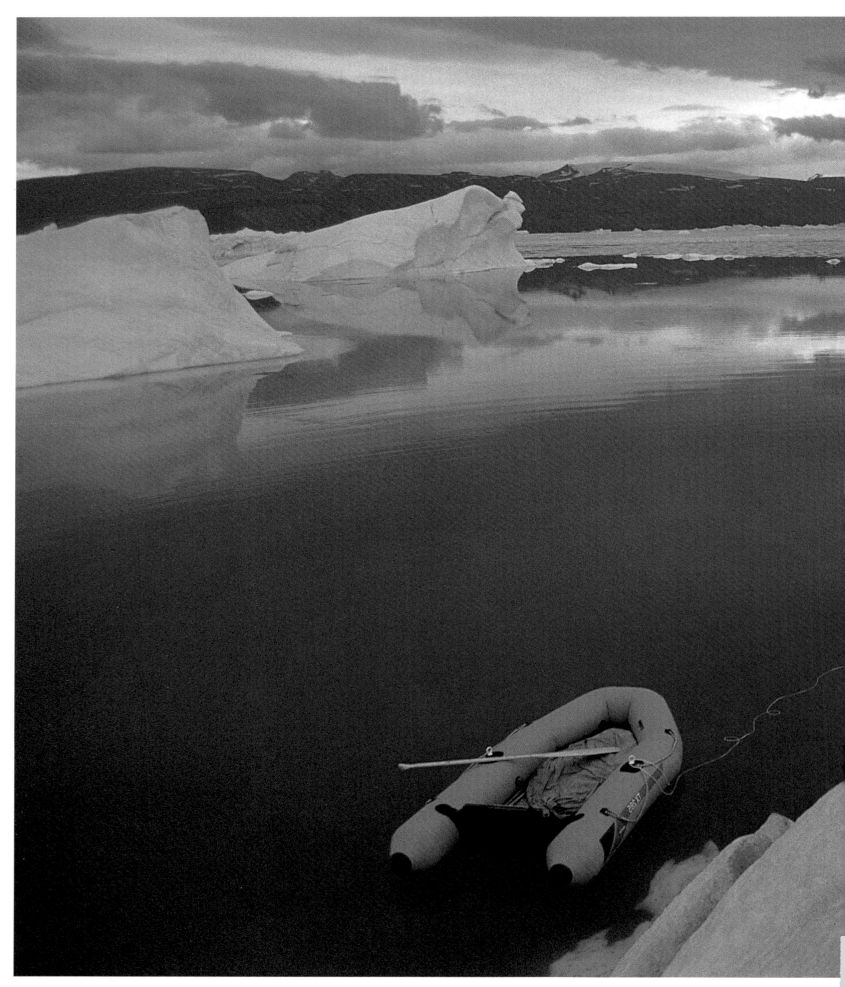

In the Arctic summer, freshwater influx from the glaciers in the northwest of Ellesmere Island ensures the thawing of the ice layer in Otto Fjord.

A ray of light in the endless Arctic night's darkness: The Northern Lights (aurora borealis) above the cone of light of the Arctic camp on Baffin Island's Soper Lake.

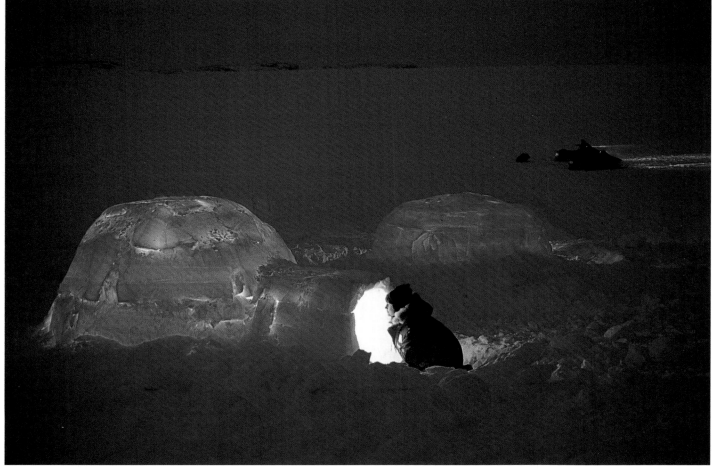

In the darkness, light spills invitingly from the tunnel entrance and cracks in the igloo near Coppermine on the northern edge of the Canadian mainland.

Tourism has long been a pillar of economic existence for many Inuit. Charley Bolt, here in an igloo entrance, accompanies tourists as their guide.

islands, and not at the geographical North Pole. The ships' magnetic compasses were therefore often useless – or worse – they often led captains astray. As northern Canada lies in the region of the Northern Lights around the magnetic pole, the aurora is often visible, as indeed it is even far south in the prairies.

THE COMPANY OF ADVENTURERS

It was not only the urge to explore which lured the white explorers of Canada to the wilds; substantial economic interests also played a role. While the search for the Northwest Passage was being carried on by royal command in the far northern islands, and whale hunters were making explorations, fur traders ensured the development and exploitation of the gigantic expanses of the mainland.

Beaver pelts were at the time the most important raw material from the new colonies in the north of the American continent. They were not needed for fur coats; in actual fact, they were required for hats: top hats, three-cornered hats and felt hats in countless variations were the fashion and status symbol among Europe's aristocrats. The barbed hair of the beavers' under-fur was ideal for the felt of these hats. Between 1650 and 1850, millions of beaver pelts were shipped from Canada to hat manufacturers in England, to be processed by the felt presses. Beavers were the living gold of the north, with the attraction being tremendous profits of up to 2,000 percent. Small wonder, then, that the fur traders moved impetuously into the wilds.

With outside temperatures at minus 30 degrees Celsius (– 22 degrees Fahrenheit) to minus 40 degrees Celsius (– 40 degrees Fahrenheit), the inside temperature of 0 degrees Celsius (32 degrees Fahrenheit), created by a blubber-lamp in the igloo, feels cozily warm.

As France had already founded its colony on the St. Lawrence River around 1600, the English were obliged to find another approach into Canada's wealth. Two renegade French coureurs de bois showed them the way: why should they not bypass France's colonies to the north? In the year 1668, British traders financed the first trading expedition to Hudson Bay; their ship, the Nonsuch, returned to London the following autumn richly laden with furs. The great era of fur trading had begun.

Tokilki Kigugtak of Grise Fjord needs agile hands and technical ability to build an igloo when he layers the snow blocks in just two hours.

On May 2 of the year 1670, the "Company of Adventurers trading into Hudson Bay," known as "Hudson's Bay Company," or abbreviated to "HBC," was founded. The company was to be of vital importance for the development of Canada. Of course, the Company's founders were not adventurers, rather they were rich investors who never traveled to Canada themselves. But their fur traders, the factors, became Canada's real adventurers and explorers. And there was much to discover: owing to founding member Prince Rupert's good connections with the English Court, King Charles II granted the HBC wide powers, including

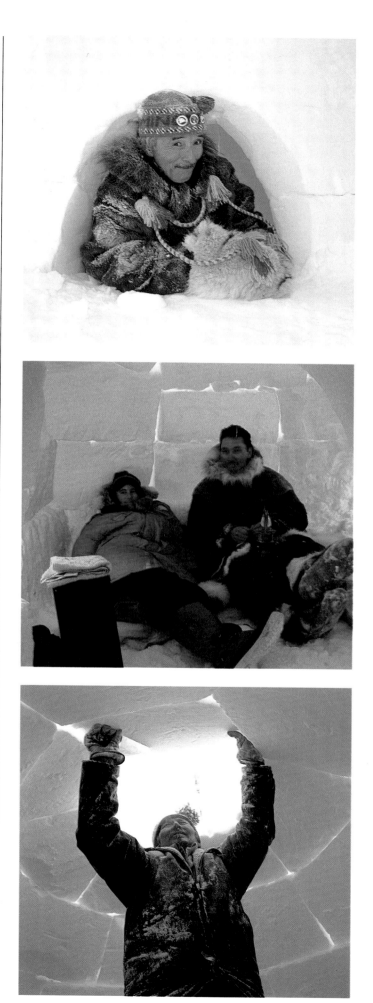

Continued on page 38

33

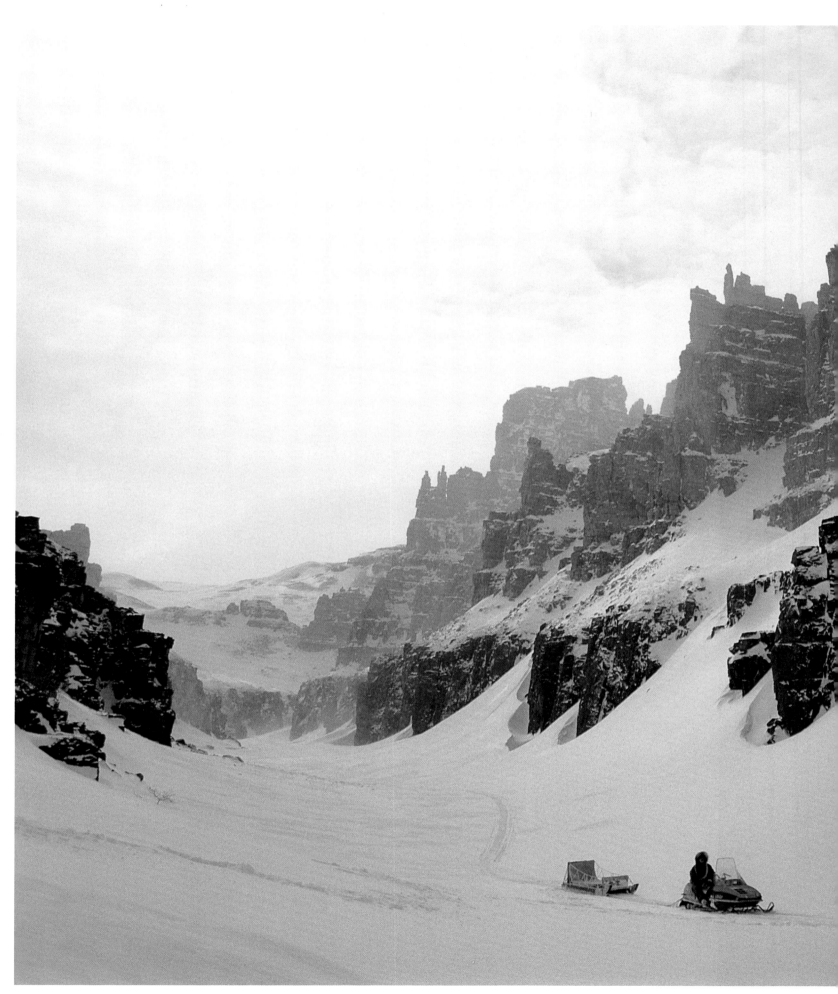

Rocky terrain accompanies these snowmobilers through snow-covered Brock River Canyon in Melville Hills between Paulatuk and Coppermine.

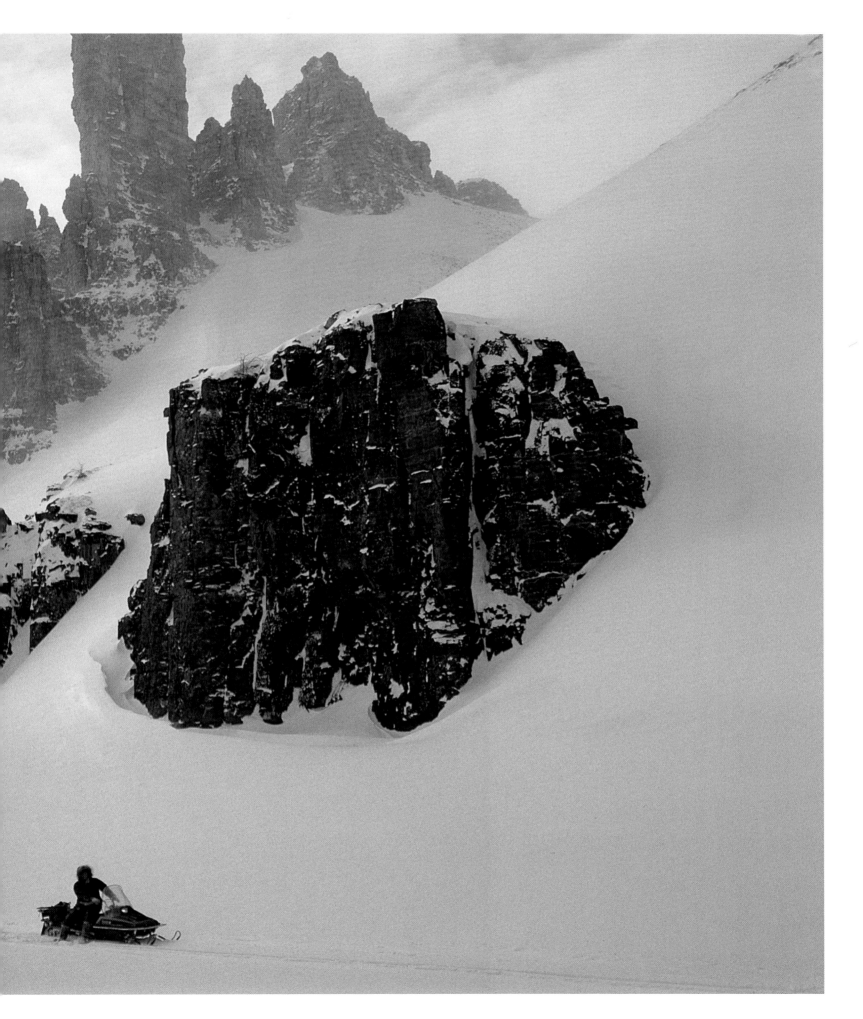

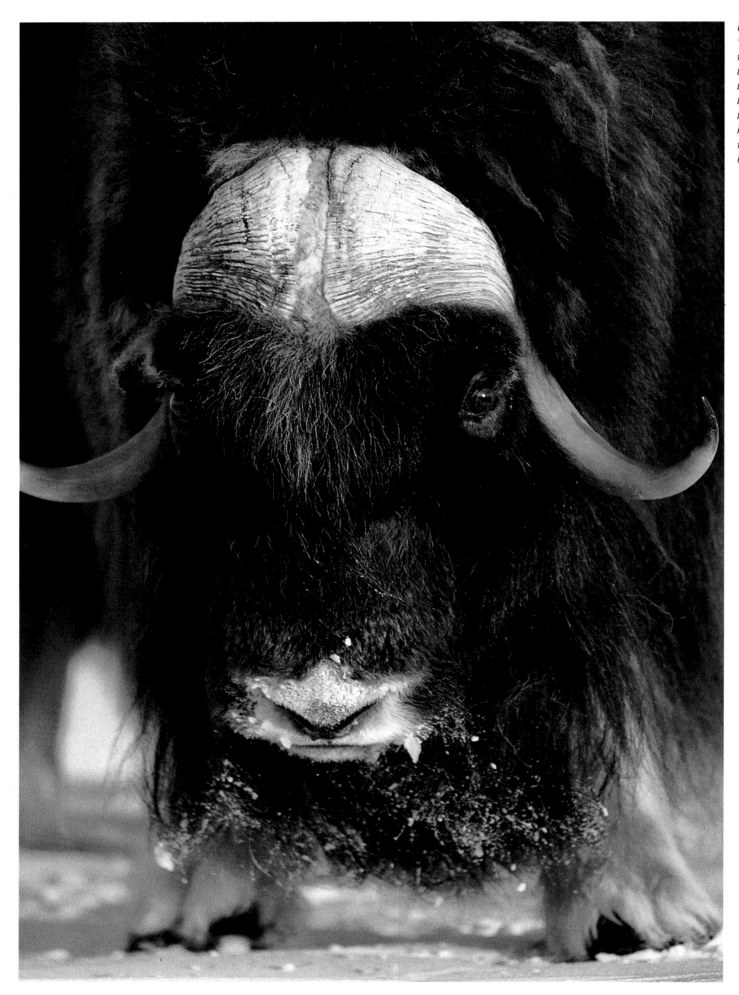

Umingmak, the "bearded one," needs fear neither the icy wind nor the biting cold of the Arctic islands; the long, shaggy hair protects the muskox's entire body.

Churchill, Manitoba: It is the beginning of October in the little town on the west bank of Hudson Bay and, as is usual every year at this time, the place is in a state of siege. Hundreds of polar bears roam around the town – sometimes even on the main street. They are waiting for the ice in the bay to freeze, so that they can hunt seals on the ice. Churchill lies on an age-old polar bear migratory route and the Lords of the Arctic do not allow their habits to be changed by a few men or houses – to the delight of visitors who photo-stalk them in off-road vehicles with iron bars.

Polar Bears are the symbolic animals of the north; even the license plates of the Northwest Territories are in the shape of a bear. Their reputation is indeed vindicated, for the white predators are at the top of the Arctic food chain and have adapted to life on the ice much better than most other animal species. In an infra-red image which measures warmth, all that can be seen of the polar bear is his breath. His coat and his thick layer of fat, which can be 11 centimeters (4.5 inches) thick, allow no warmth to escape to the outside.

Of course the bears are not alone in the Arctic, but live among relatively species-poor but highly fascinating flora and fauna. The great dividing line between the species is formed by the tree line, which runs from the Mackenzie Delta in the west to the southern tip of Hudson Bay – far south of the 60th degree latitude – reaching the Atlantic at Ungava Bay in northern Quebec.

South of this line there still thrives a comparatively luxuriant vegetation, with

SURVIVAL AT 40 BELOW

Flora and Fauna of the North

In the northern expanses, a fascinating world of animals lives in close association with climate and vegetation.

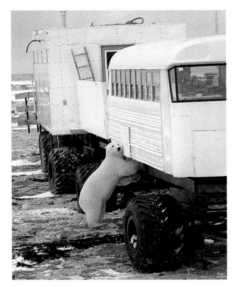

The polar bear does not fear even this tundra buggy on high wheels.

sparse woods of spruce, pine, poplar, birch, and numerous berry bushes. These boreal forest areas are the habitat of the moose, beaver, porcupine, chipmunk, fox, wolf and lynx and – in Wood Buffalo National Park – even a herd of some 3,000 wood bison.

Survival is more difficult north of the tree line in the tundra: it is only on the southern edge that there still thrive some Arctic dwarf willow, stunted black spruce and small shrubs. On the permafrost of the cold deserts of the Arctic Archipelago, farther north, only grasses and sedge, moss and lichen grow as a rule. But animals can be found even in this forbidding landscape: Arctic hares, Arctic foxes, caribou and even wolves live high in the northern islands.

In addition to thick layers of fat, such as that of walruses and seals in the Arctic Ocean, land animals of the tundra often have to develop additional survival strategies. According to the season, the caribou, the North American reindeer, travel in gigantic herds to the best feeding areas. The muskox takes a hedgehog position against attacks by wolves or bears; the grown animals form a circle with their horns pointing outward against the predators, while the calves remain inside the circle – a tactic which proved fatal when the animals were faced with the whalers' firearms, so that by the year 1900 the muskox was almost completely extinct, causing a partial hunting ban.

Especially impressive and interesting to observe is the diverse bird world of the north. Hundreds of thousands of snow geese, rain crows, gannets, and puffins, as well as some 80 other bird species, spend their summers in the Arctic; among them are such rare species as the gyrfalcon, which is threatened with extinction. Most of the birds move south in winter, but some, such as the spruce grouse, snowy owls, ravens and even some falcons, remain in the north through the dark winter. There is even a species of gull, the ivory gull, which lives the entire year on the pack ice – a real survival artist. *Karl Teuschl*

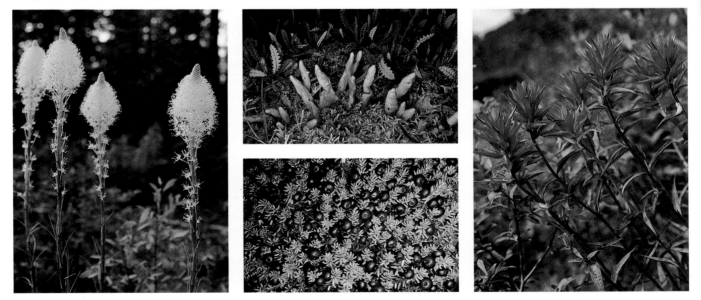

Despite the short summer, the Arctic regions are covered in a sea of colorful blooms, be they shrubs, grasses, lichens, liverworts or berry bushes.

exclusive trading and colonization rights in the territory traversed by rivers flowing into Hudson Bay.

Just how big these landed properties were was not known exactly at the time. But the HBC's territory, Rupert's Land, stretched from Labrador's mountains to the Rockies, approximately four million square kilometers (1,600,000 square miles). Their trading area comprised one twelfth of the world's surface! The Hudson's Bay Company established almost 180 trading posts in its empire, posts which became Indian and Inuit settlements and later Canada's modern cities. For centuries, fur trade determined the lives of the Native Peoples in the north. Dene and Inuit hunted for the Hudson's Bay Company, receiving in exchange from the factors the arms, metal pots, steel knives, and all the other necessities of the modern world at more or less the going value.

During expeditions, which often lasted for years, HBC traders explored the extensive continent, setting out from their posts on the western banks of Hudson Bay. Such an explorer was Samuel Hearne, who discovered Great Slave Lake in 1772, while exploring the estuary of the Coppermine River on the Arctic Ocean. Shortly after, the fur traders of the North West Trading Company, founded in Montreal in 1780, arrived. Their traders, mostly hard-bitten Highlands Scots, advanced over the Rocky Mountains. Their most famous discoverer was Alexander Mackenzie, who in 1780 followed to the Beaufort Sea the river which was to be named after him, even reaching the Pacific three years later. He was the first European to cross the American continent.

During their long reconnaissance tours through the wilds, traders and trappers quickly learned the necessity of living like the Dene and Inuit in order to survive in this country. They set out by dog-sled and in canoes, and during their trips lived by hunting and fishing, deprived of the comforts of civilization. They frequently married Native women. This brought about a good relationship with the tribe in question, and in any case there were no white women in Canada's north. The numerous descendants of these unions developed over the centuries into their own ethnic minority in Canada, the métis.

Life was hard for the trappers and traders, but it must have been much harder for their wives. This is revealed in Samuel Hearne's diaries, in which he recounts the view of Dene Chief Matonabbee: "Women," added he, "were made for labour; one of them can carry, or haul, as much as two men can do. They also pitch our tents, make and mend our clothing, keep us warm at night; and, in fact, there is no such thing as travelling any considerable distance, or for any length

In the sunny spring, always friendlier than the Arctic winter snow storms: the Inuit village of Paulatuk on Darnley Bay in Amundsen Gulf.

The antler-bearing caribou is coveted for its meat as well as for its skin, which is used for making warm clothing, is hunted by Inuit and Dene.

This cleaned polar bear skin is sun-dried before being sold. Depending on its size and quality, it will bring in 1,000 to 3,000 dollars to the successful hunter.

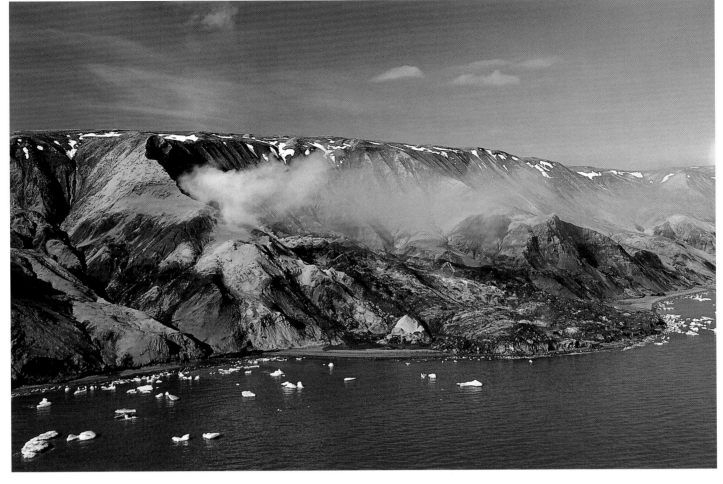

Smoking Hills: When the sulphur particles trapped in the stones come into contact with the shale stratum, the mountains above Franklin Bay in Amundsen Gulf begin to smoke.

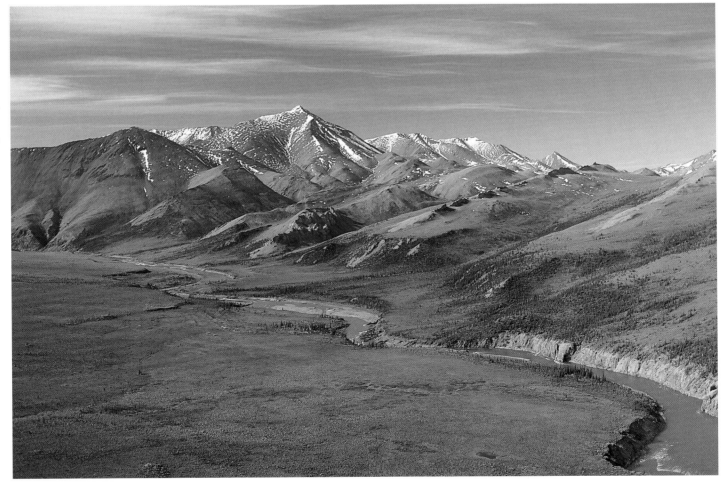

Firth River, leaving behind the mountain ranges of the British Mountains in Ivvavik National Park on the northern tip of the Yukon Territory, clears its path toward the Beaufort Sea.

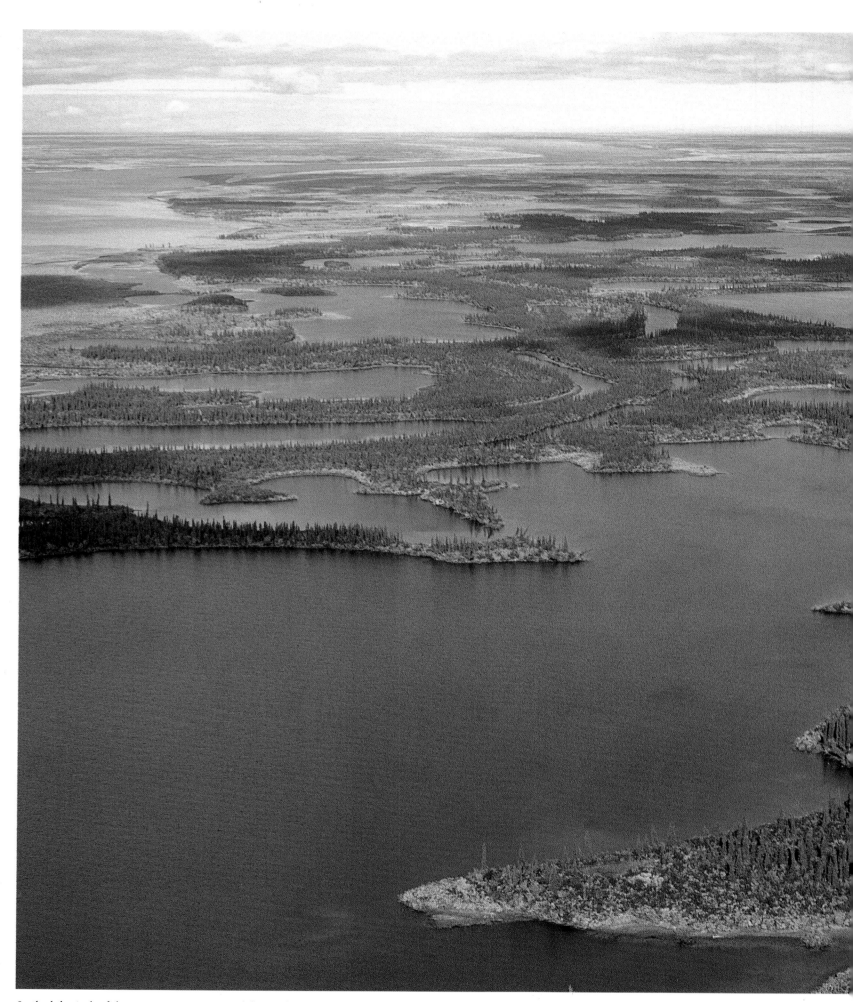

In the labyrinth of the numerous river arms, lakes and swamps of the Mackenzie River Delta, diverse life blooms in the short Arctic summer.

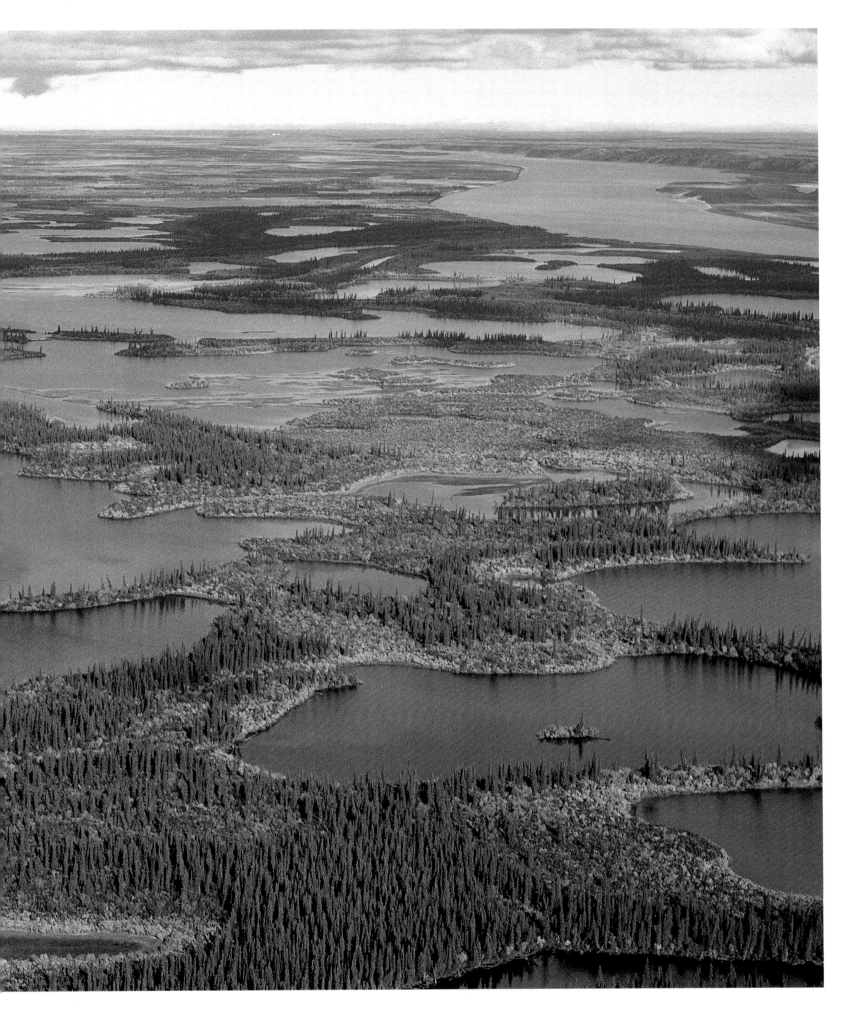

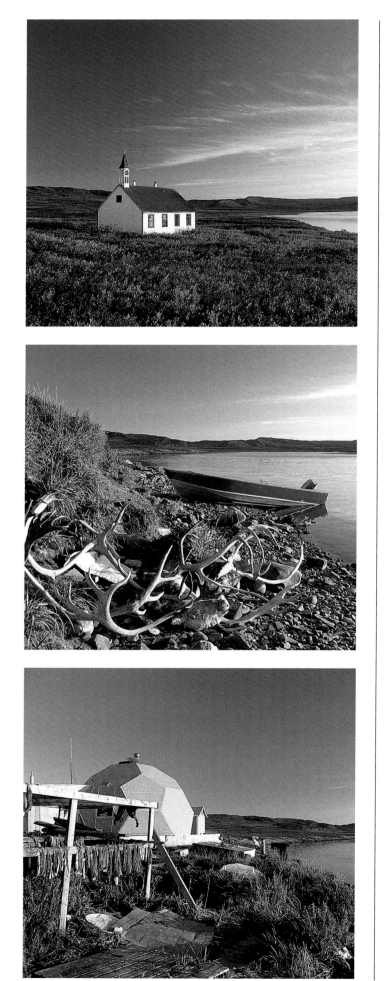

of time, in this country, without their assistance. Women," said he again, "though they do every thing, are maintained at a trifling expence; for as they always stand cook, the very licking of their fingers in scarce times, is sufficient for their subsistence." So much concerning the role of the uncounted, nameless Dene and Inuit women, without whom the exploration of the north would hardly have been possible.

Until late in this century, the fur trade and the HBC determined the life of people in the north. Although the Hudson's Bay Company ceded its formidable holdings in the year 1870 to the newly founded Canadian state, daily life in the villages has continued to be partially determined by the trading posts. Indeed, it still holds sway as employers, the only shopping possibilities, the social meeting place – simply the focal point of the village world.

The old mission church at the former trading post of Bathurst Inlet, on the bay of the same name in Coronation Gulf, has been converted today into a residence.

THE NORTH IN A STATE OF FLUX

Despite the movement of the explorers and traders through the northern wilds, the lives of the Native People were hardly changed at first. It was not until the middle of the last century that in the north the change from stone age to modern times finally began, and around 1900 this development was accelerated. But this entrance into modern times was the start of a long period of suffering for the Inuit and Dene.

The giant caribou herds that wander between the tree belt and the tundra have for centuries been hunted by Inuit and Dene.

The Inuit in the east and extreme west of the Arctic now came increasingly into contact with white whalers, who hunted in Davies Strait and Hudson Bay, in Lancaster Sound and – coming from the Pacific – in the Beaufort Sea, and whose ships often spent the winter in the Arctic. But with the whalers came whiskey and European diseases: influenza, smallpox, measles and a multitude of venereal diseases. These diseases, formerly entirely unknown in the Arctic, infected entire Inuit tribes, making some of them extinct.

Although the first missionaries made their appearance in the north at the same time, building churches and schools, this was of little help. Lay missionaries, Moravians, Jesuits and Anglicans brought European ideologies and a new God – as well as an increased insecurity for the Native Peoples: their old world, with its values, rituals and traditions, was suddenly no longer of value. Although imports from the civilized south changed and eased their daily lives, they also increased their dependence on the white man's world. The result was an increasing loss of identity.

The traditional basic food of the Arctic mainland Inuit is fish, air-dried and later stored away for the winter.

The early explorers and fur traders, still needing the adept and skillful Inuit and Dene Indians as pathfinders and fur suppliers, evinced no interest in changing the stone-age life of the original inhabitants. But

Trees and bushes of the Horton River Valley turn to the strongest red in autumn. The color is due to their protective location on slopes, where they were pampered by the summer sun. On the high plateau, right in the picture, icy winds allow only a scanty growth on the polygon tundra (see page 18).

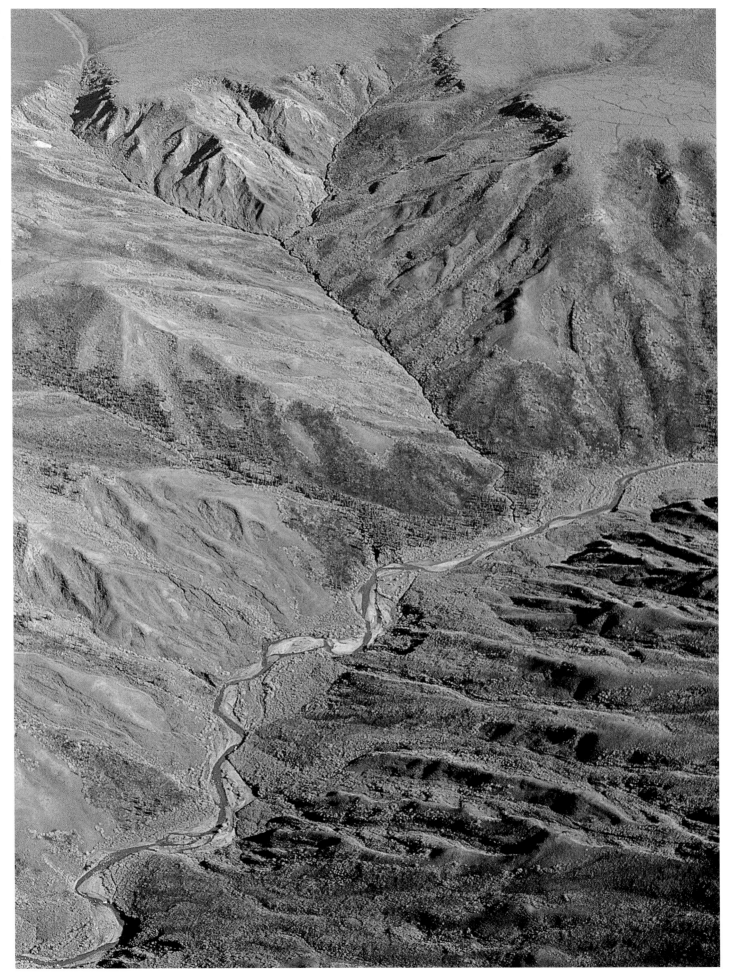

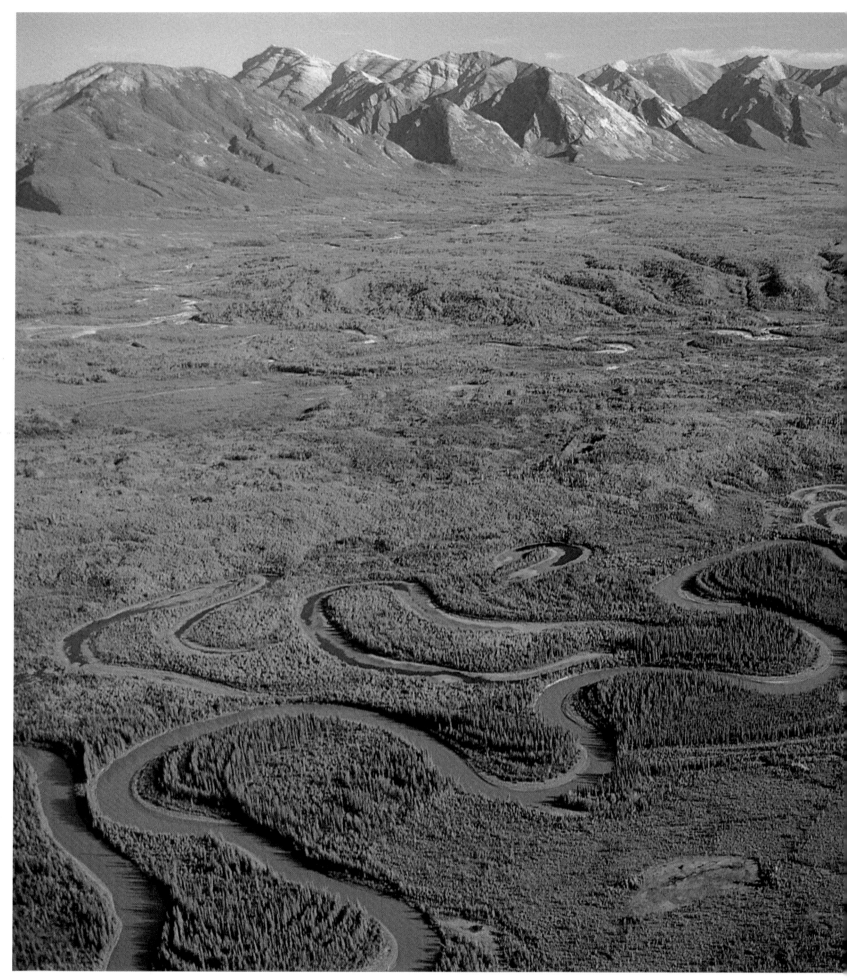

Camsell River winds in numerous bows through the Canadian bush between the Mackenzie and the Franklin Mountains.

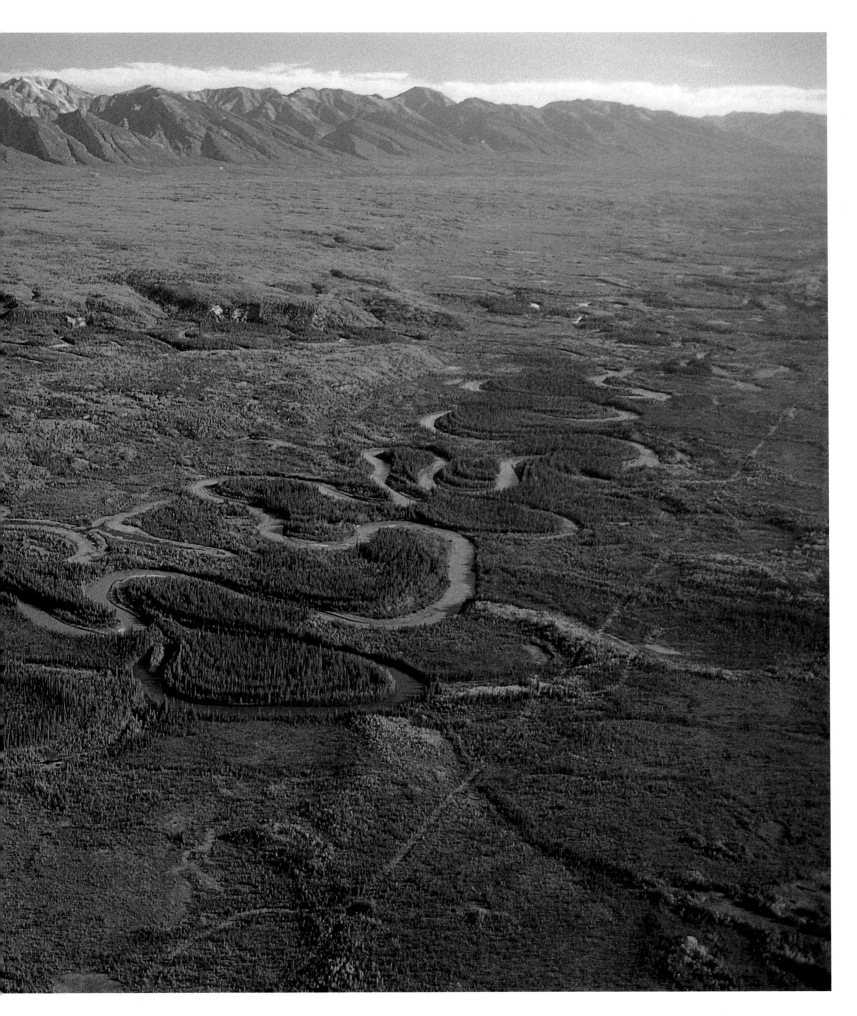

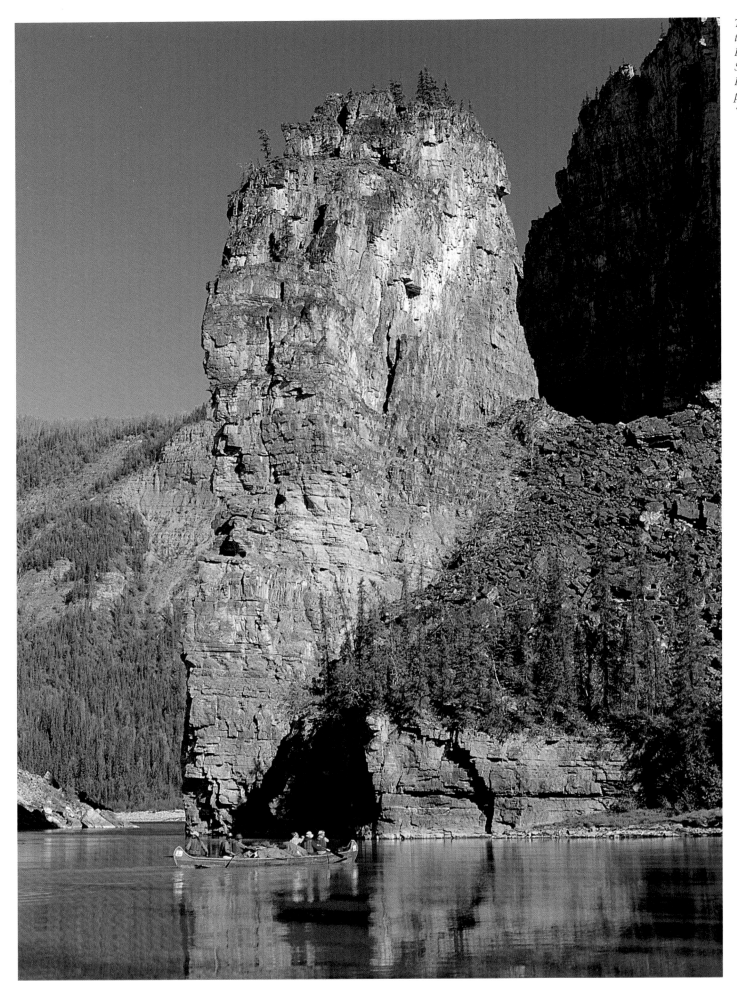

The steeply towering Pulpit Rock narrows South Nahanni River at the point known as "The Gate."

now governments and missionaries tried to settle the Native Peoples, and have them adapt to the living and working habits of the whites, with the result that alcoholism and suicide among the until then mostly nomadic peoples rose to precipitous heights.

The greatest changes, however, were experienced in the Yukon region. Gold was discovered on the Klondike in 1896, and, just two years later, Dawson City had 30,000 inhabitants (see text insert page 54). It is true that most of the adventurers soon moved on, but some stayed, settling in the Yukon Territory. But the north had already demonstrated what wealth was to be found there. In the mid-1930s, when gold was again discovered in Yellowknife Bay's volcanic rock on the northern banks of Great Slave Lake, the Arctic's first mines were developed, and Klondike fever began anew.

Wild west romance in the Canadian bush: campfire near Fort Smith at the edge of Wood Buffalo National Park.

The next developmental leap was brought about by the Second World War. Alarmed by the threat to Alaska by the Japanese, American military strategists and the Canadian government began building a road from British Columbia through the Yukon Territory to Alaska. Eleven thousand soldiers and engineers worked during the summer of 1942 on the military road, battling through formidable swamps, building bridges and camps along the way. Eight months later, the Alaska Highway was completed – a 2,300-kilometer (1,400-mile) route through the wilderness. The Alaska Highway was the first road in the north and, tarred in the meantime, is the only land connection with Alaska. The building of the road provided the Yukon Territory with an economic upswing, new towns and the first land-based tourists to the north.

The Arctic played an important role as well during the 1950s Cold War. Canada and the USA established a system of twenty-one early warning radars along the Arctic Ocean, the DEW (Distant Early Warning) Line. To legitimize Canadian sovereignty in the north, even the Inuit were used as a political tool. The Canadian government established the settlement of Grise Fjord on the southern coast of Ellesmere Island. The continent's northernmost island had been completely devoid of people, and now Inuit were being settled here, to support Canada's claims to the Arctic.

But the most significant innovation after the Second World War was the plane: little airports shot up all over the north, a journey formerly lasting a week or even months by boat or dog-sled now shrank to only a few hours' flight. In the 1940s some people starved to death, but now relief supplies and doctors could quickly be on the spot.

The Arctic was first mapped by aircraft during the 1950s. It was the advent of aircraft that really led the little villages in the north into modern times. Even more than polar bears, bush pilots became the symbol of the Northwest Territories. Today, they carry equipment, mail and medicine to the inhabitants of the north. They fly geologists and prospectors to the most remote corners – and the modern wilderness tourists to the loveliest spots in the country.

NATURE'S TREASURES CANADA'S NATIONAL PARKS

Selected regions of the country should be declared national parks and left intact in their original beauty for posterity and "... for the well-being, advantage and enjoyment of Canada's population," the parliament in Ottawa wrote in the year 1887. The sublime mountain

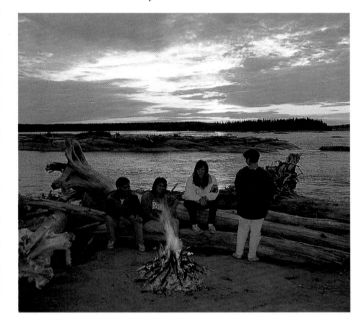

wilderness of the Rocky Mountains around Banff was placed under protection as Canada's first national park. Since then, over the last decades, the federal government has established approximately forty other national parks, particularly in the north.

The declared goal of nature conservationists is to maintain completely unchanged for posterity at least one national park in each of the thirty-nine typical nature regions of Canada. In the beginning, it was mostly spectacular landscapes such as the Rocky Mountains that were placed under protection; however, during the last decades – almost all the parks in the Arctic were created in the last twenty years – habitats for threatened species and especially for ecological systems were also set aside.

There are nine national parks in the Yukon and Northwest Territories today, and three more are planned. Among them are famous and yet easily accessible parks, such as Nahanni National Park, furrowed with deep canyons, and with hot springs,

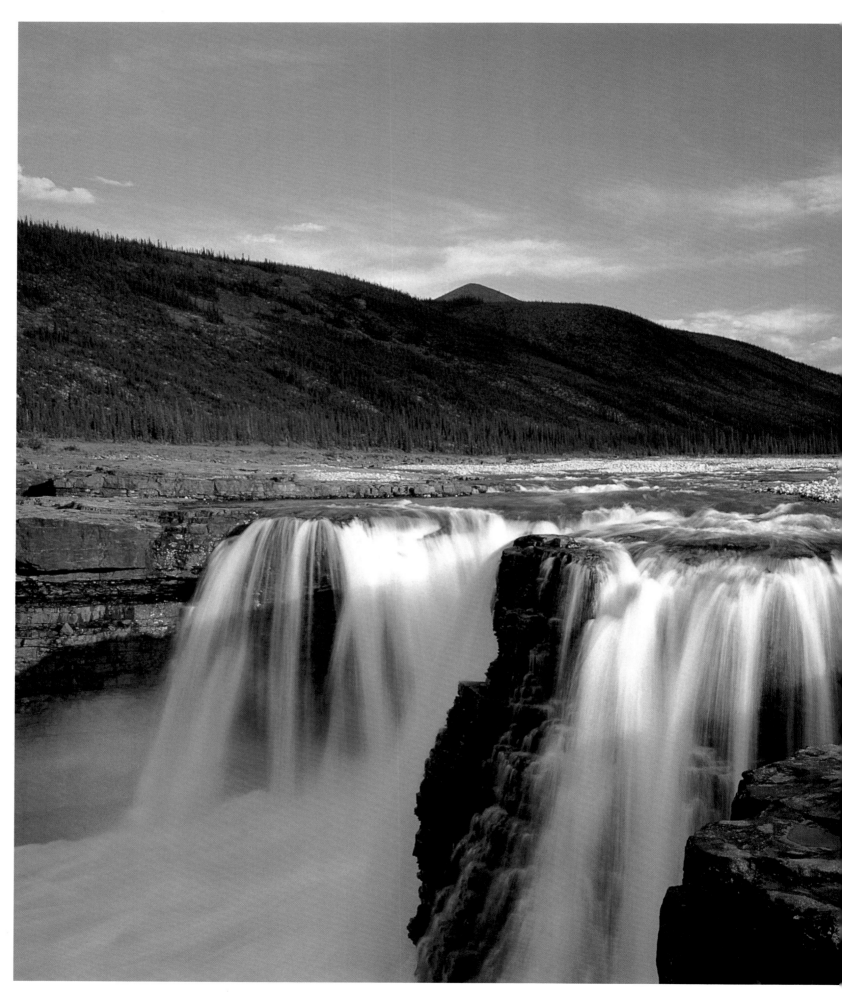

The Carcajou River plunges west of Norman Wells, near Canol Road, roaring into the depths.

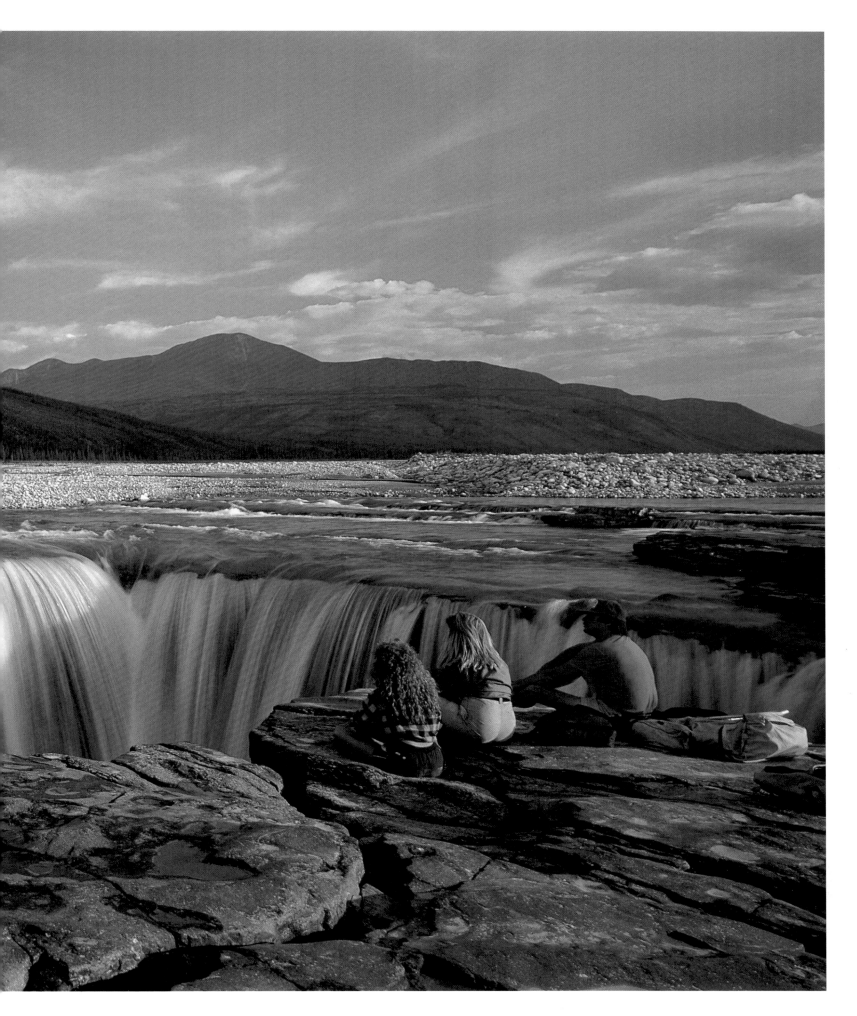

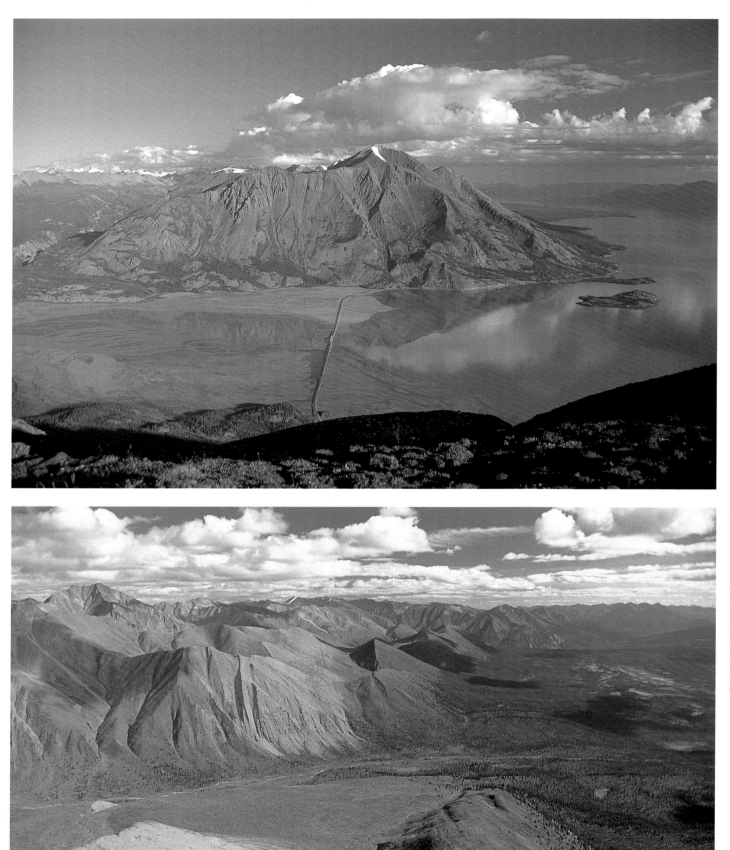

At the estuary of Kluane Lake, the Alaska Highway cuts dead straight through the Slim River alluvium before reaching the foot of Sheep Mountain.

Flying weather is not always as sunny as this in the Ragged Range of the Mackenzie Mountains: blizzards, fog, icy rain, and white-outs that wrap everything in a diffuse white, often make flying an adventure.

Fantastic vistas from Kluane National Park's Visitors' Center: looking over red-gold foliage toward the mighty ice-fields of the St. Elias Mountains.

The Yukon "Silver Rush" on Keno Mountain is a thing of the past. All that remains of the ghost town of Keno is the pretty church in front of the "Silver Mountain," now riddled with holes.

When the driver of a car along the Dempster Highway has climbed the North Fork Pass at 1,300 meters (4,225 feet), the tree line is already behind him.

seething rapids and icy caves; and Kluane National Park, which preserves the glacial world of St. Elias Mountains around Canada's highest mountain, 5,959-meter (19,400-foot) Mount Logan. Together with neighboring Wrangell-St. Elias National Park, which is in Alaska, Kluane National Park forms the largest nature conservation area in the world: 55,739 square kilometers (21,800 square miles) of remote highland wilderness without roads or cable railways.

Along with Wood Buffalo National Park in the delta of the Peace and Athabasca Rivers, the two above-named parks have been designated World Heritage Sites by the UN. They are therefore unique landscapes and ecological systems particularly worth preserving. However, the other parks, those which were not established until recently and which are still completely unknown nature protection parks, are the equals in their magnificent wild beauty of the three more famous parks.

Auyuittuq National Park, "the land which never melts," awaits with massive granite peaks and glaciers (see also text insert on page 77). The Ivvavik and Vuntut Parks in the north of the Yukon Territory are home to some 150,000 head of the porcupine caribou herd. They are also the brooding-place for hundreds of thousands of snow geese and other migratory birds. Further north on Banks Island in Aulavik National Park, which was created as recently as 1992, herds of musk-oxen graze – a total of 9,000 head – evoking primeval times. Ellesmere Island National Park impresses its visitors with Arctic deserts and steep cliffs dropping sharply to the Arctic Ocean, as does North Baffin National Park with great bird colonies and spectacular fjords. The list of overwhelming highlights offered by nature is never-ending.

What is most impressive in all northern parks, however, is their unspoiled character. In the south, some four million visitors jostle every year in the famous Banff National Park in the Rockies, but only some 1,500 tourists, if as many as that, visit the equally spectacular Nahanni Park, and Nahanni is one of the most visited new parks in the Territories.

Only Kluane and Wood Buffalo National Parks can be reached by road, but the hinterland can be attained here, as it can in all the other parks in the north, only by airplane, by foot, by boat or by dogsled. And exploration is difficult; there are no huts with country restaurants, no established paths, no accommodation whatsoever except for tents carried on the tourist's back. But those intrepid travelers – properly prepared – who undertake such wilderness tours are richly rewarded with a nature experience such as can be found in very few other regions in the world.

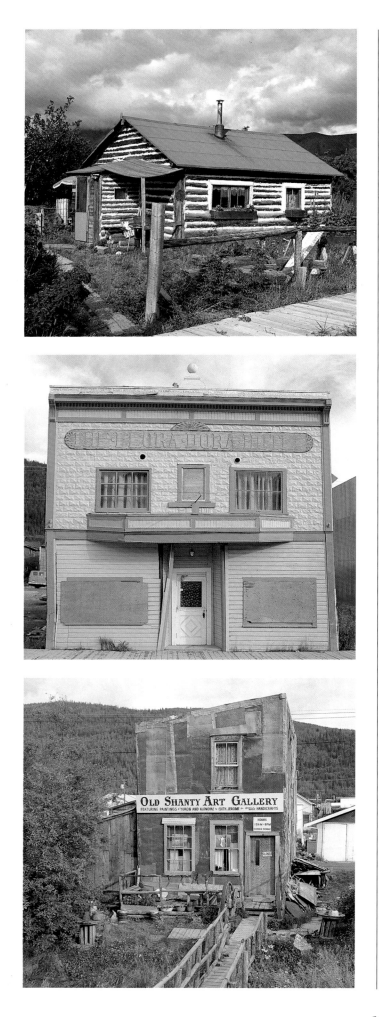

DANGER THREATENS WORLD'S END

Despite the gigantic conservation regions, Canada's seemingly never-ending wilderness is no longer a healthy world. Inuit and Dene lived for centuries in the soil-poor wooded and tundra regions of the north, but they were far too few to destroy nature in the extensive land, and they traditionally ensured that only the animals which they actually required for the tribe's survival would be hunted and killed. It was the modern industrial man who lost all respect for nature, and his influence can now be felt even in the remotest regions – unfortunately, mostly in a negative way. Pollutants have fouled waters and despoiled vegetation.

Canada is a civilized country that respects species protection treaties, and has promulgated strict laws for the preservation of nature. But the country is so big that game keepers and other custodians are often too far away to be effective. And so it can happen occasionally that an irresponsible hunter and "collector" will serve himself from nature: rare gyrfalcons, trained in the Near East to hunt, are traded on the black market for over 100,000 dollars per bird. Although there are very strict shooting quotas for polar and grizzly bears, a master game keeper can always be found who will allow his wealthy clients to poach. Poaching even occurs in the national parks, for this is where trophy hunters, competitive hunters whose object is to bag large game, can find the oldest and loveliest Dall sheep and grizzlies.

However, these are individual cases – poaching is certainly not the Arctic's biggest problem. Much worse are the effects of industrial air pollution, originating far to the south. Due to the prevailing wind currents, pesticides and detrimental chemical material from American and European conglomerates are carried right up to the far Arctic, where they are concentrated. These poisons then collect in the Arctic's food chain. As an example, there has been found five times the amount of pollutants in the breast milk of Inuit women compared to the breast milk of women in large southern cities.

The feared global warming by the greenhouse effect would have particularly dramatic consequences in the north as well: the tree line would be pushed further to the north; glaciers would melt, causing the world's sea level to rise; and the permafrost would thaw. The huge amount of methane gasses enclosed in the swamps – frozen until today – would be released, thus increasing the planet's warming, fatal feedback effect. Although the ozone depletion over the Arctic is not as serious as the depletion over the Antarctic, it is

Traditional Yukon log cabin in Carcross: the chinks between the trunks were caulked with moss and then grouted white.

Reminiscent of Dawson City's heyday: the Flora Dora Hotel, in which gold prospectors tried their luck with the ladies.

A gallery owner has established himself in a former Dawson City saloon, in order to offer his objets d'art.

52

Continued on page 56

*The White Pass &
Yukon Route with
the Carcross train
station owes its
existence to the
gold rush around
the turn of the
century. The
train connected
the Alaskan
harbor of Skag-
way with White-
horse. From there,
it went downriver
to Dawson City.*

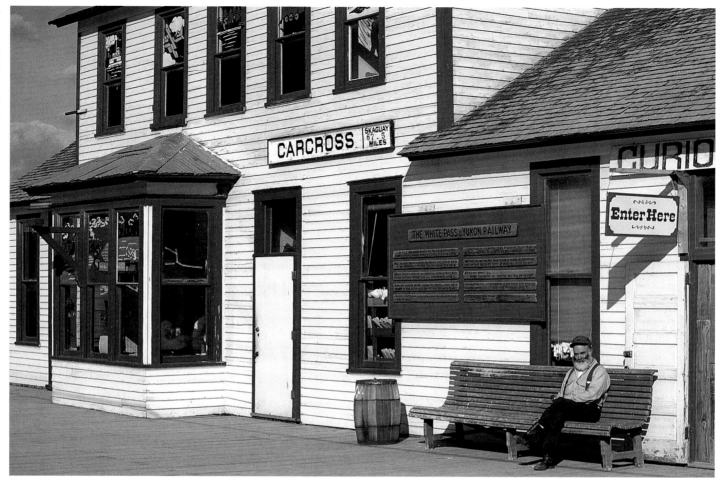

*Since the 1980s,
Dawson City has
developed into a
popular tourist
destination
featuring numer-
ous houses, some
restored and
some built in
turn-of-the-
century style.*

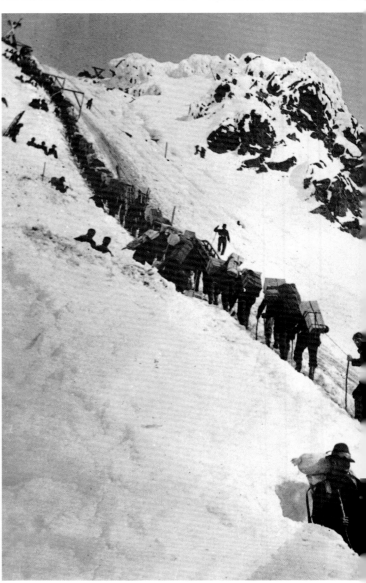

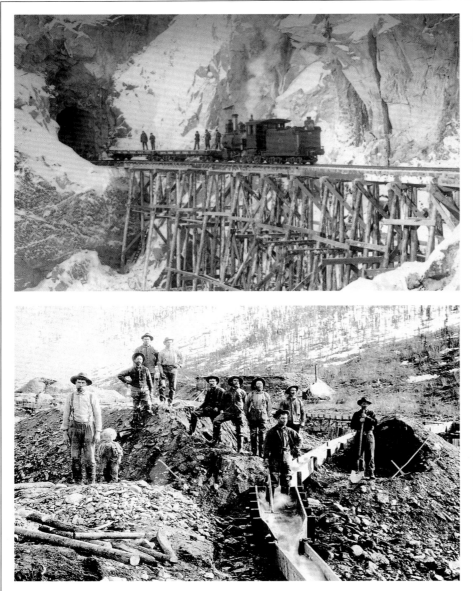

GOLD IN THE KLONDIKE!

History of the Gold Rush in the Yukon Territory

The hopes of the gold prospectors of striking gold on the banks of the Klondike and finding its richest tributary dried up at the turn of the century.

Mile-wide cinder tips and rubbish heaps gape on the banks of the Klondike and its tributaries, silent witnesses to the most fascinating gold rush in the history of the north, a catalyst for a series of later mineral discoveries. Even now, almost one hundred years after thousands of adventurers burrowed through the frozen earth, nothing grows on the washed-out gravel. And still today, a few tireless prospectors can be seen with bulldozers and great hydraulic hoses, searching for the tempting gold metal. In the year 1990, the yield was approximately 130,000 ounces. An ounce was worth 400 dollars. That is a total of almost 50 million dollars – and those are just the slim pickings remaining after the most turbulent gold rush the world has ever seen.

It all started in the 1890s. After the California gold rush, the gold prospectors moved north year by year; they had discovered gold in Oregon and British Columbia and finally had surged into Alaska and northern Canada.

Then, in the summer of 1896, came a major find, by a certain George Carmack and his two Indian friends, Skookum Jim and Tagish Charlie, who were hunting moose in the Klondike River valley. Robert Henderson, a Canadian gold prospector, had previously mentioned something to them about gold dust he had found nearby, and the three, by keeping their eyes open, made a find in a small tributary, Rabbit Creek. The nuggets lay in thick layers in the stream bed. A bonanza! A few weeks later, miners pouring in from the entire region had staked their claims along the banks of the creek, now rebaptized Bonanza Creek.

The news did not reach the outside world until one year later. In July 1897, the first steamer from the north arrived in Seattle with over a ton of gold on board. The news spread like wildfire. The call of the north had never been as loud as it was then. Some 50,000 adventurers set out – from America, Australia, indeed, even from England and Germany.

Reaching the Klondike the same year was difficult. The gold diggers had to travel to the harbor of Skagway via the Inside Passage in late autumn, cross the storm-lashed passes of the Coast Mountains in winter, in order to reach the gold

The legendary gold rush on the Klondike River one hundred years ago is documented with historical photographs. The adventurous journey to the hoped-for wealth led over deep gullies and at the cost of miserable back-breaking work.

Building a wooden bridge for railroad tracks (top left); miners panning for gold (bottom).

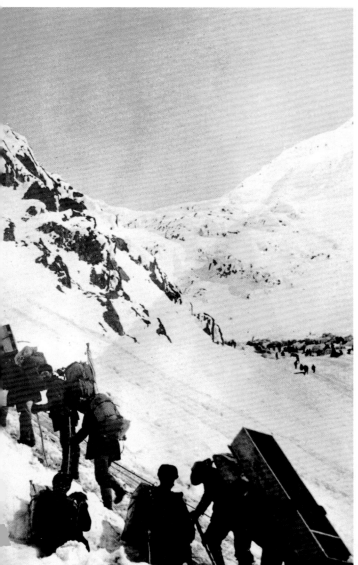

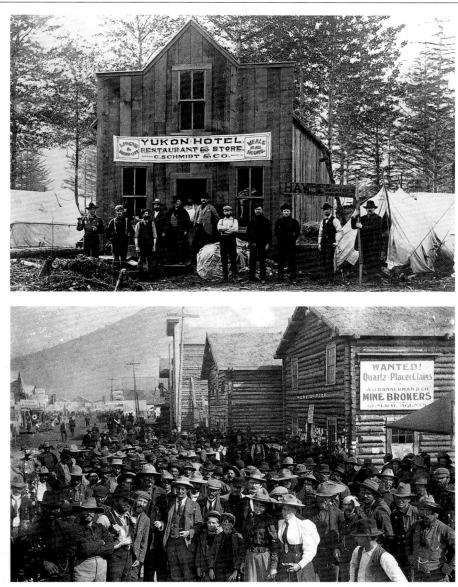

Many gold prospectors died of strain during the Chilkoot Pass crossing (center).

The gold-digging city of Dawson City boomed, within a very short time housing some 30,000 inhabitants. Hotels (top right) and entertainment establishments flourished and people waited for news from home outside the Post Office (bottom).

fields of the Klondike in time for the next spring. Chilkoot Trail, or Klondike Gold Rush Trail, was the most infamous and difficult stage of the route: 25 kilometers (33 miles) uphill and down. The last bit of the pass even had to be managed via steps which had been hacked from the ice – the Golden Stairs. The gold prospectors had to make this trip perhaps fifty times, for all had to bring equipment and supplies to last a year – one ton of weight in total. The Canadian Mounties ensured that the decreed weight was observed. Just below the pass, they controlled each miner's entry. Those who had managed the trail all the way to Lake Bennett could not move farther north until the ice break-up in May. In wooden boats they made themselves, thousands of gold diggers rowed upriver on the Yukon River in the spring of 1898 to the legendary gold claims on the Klondike. Some 30,000 men dug that

summer in the golden earth, and many claims brought their proud owners 100,000 dollars a month.

Dawson City, named for the geologist, the newly created city on the estuary of the Klondike into the Yukon River, was soon known as the "San Francisco of the North," and became the largest city in all of western Canada. In summer, paddle-wheel steamers brought Irish whiskey and French wines, pianos and entire bar facilities on the Yukon River via the Bering Strait. Saloons, hotels and even opera houses shot up over night. Talented "ladies" helped the miners to dispose of their nuggets.

Gold valued at some 100 million dollars was washed out of the sand during those wild years. And at that time, the gold value per ounce was only 16 dollars. At today's prices, the find would have been worth 2.5 billion dollars. The great Dawson City boom lasted only a few years. In

the summer of 1899, a new, larger gold find was made in Nome, Alaska, and another find was made near Fairbanks in 1901. The adventurers moved on, leaving the fields to the mining companies, who dug in the stream beds for decades with gigantic shovel dredges. Dawson City almost lapsed into a ghost town, and only memories remained of the gold fever, memories such as those immortalized by Jack London in his novels. But probably no one has better captured in words the lure of gold than Robert W. Service, the bard of the Klondike:

There's gold, and it's haunting and haunting,
It's luring me on as of old;
Yet it isn't the gold that I'm wanting
So much as just finding the gold.
It's the great, big, broad land 'way up yonder,
It's the forest where silence has lease;
It's the beauty that thrills me with wonder,
It's the stillness that fills me with peace.

Karl Teuschl

conceivable that an "ozone hole" could develop in the Arctic, too. This led to restrictions on the use of some chlorofluorcarbon compounds in Canada.

Many of our global systems are closely connected to the Arctic and their mechanisms have not yet all been researched by scientists. For example, in only three known places in the Arctic Ocean does cold water sink from the surface to the deeps, influencing the world's oceans. What would happen if these Arctic currents were to cease? If the Gulf stream were to change

direction, Europe might congeal in a new ice age. Environmental issues are at stake here.

But there is not only bad news. Over the last decades, exemplary successes have been recorded in nature and species conservation. An example is the wood bison, which was already on the list of species which were becoming extinct, when in 1957 a few of the purebred animals were discovered in a remote region of Wood Buffalo National Park. They were brought to their own protected area on the west bank of Great Slave Lake, so that they would not mix with the other bison in the park, a cross between wood and plains bison. Today, the number of wood bison in the herd is over 2,000 animals.

Even more spectacular was the saving of the whooping crane, whose 2.2-meter (just over seven-foot) wing-span classifies it as the largest North American bird. The snow-white birds with the striking black-red head marking were almost extinct as early as 1940 – there were only 15 whooping cranes left! In an emergency program, young cranes were artificially incubated; their winter quarters on the coast of Texas were placed under the strictest protection, as was their brooding area in the salt marshes of the Athabasca River. Today, the number of cranes has risen to more than one hundred, probably ensuring the survival of the species.

CANADA'S NORTH – TODAY AND TOMORROW

The last decades have once again brought about great changes for the people of the north. In particular, the Native population's situation has changed for the better. Thanks to modern medical care and acquired resistance to the new infections, life expectancy has risen sharply. In the 1960s, for example, the infant mortality rate was 120 deaths per 1,000 births; today the ratio is 12 to 1,000. The number of Inuit has almost tripled over the last thirty years, to some 21,000 people today. The Dene record similar high growth rates.

In the remotest villages as well, people now live in modern houses, which, like all other supplies, are delivered by cargo barges or by plane. The Inuit and Dene have their own radio programs, their own teachers and even their own companies. Some are bush pilots; others work for the government or in mining; still others are lawyers or doctors.

However, high unemployment in the north is still rife, alcoholism is widespread, causing grave concern indeed among the elders, and young people are leaving for the cities. Old cultural ties have been relaxed, and people are searching for new lifestyles. Hunting and trapping have also decreased, since European and US nature conservationists have organized a very effective boycott of fur items.

The Inuit and Dene never had anything to do with seal slaughterers, who far to the south clubbed the seal babies to death for their white fur. But they were nonetheless considered guilty, and were, therefore, robbed of their traditional income and lifestyle. Even the new employment in the oil industries and in mining will never replace their outdoor hunting life in the wilderness.

Today there are televisions in the living rooms of even the smallest towns, and every village can be reached via satellite telephone. Yet civilization's influence has hardly changed the wild country at their doorstep. The north is still very sparsely populated, but

Dempster Highway, "The Road to Adventure," runs beyond the Arctic Circle through a spectacular wilderness to Inuvik in the Mackenzie Delta.

From the summit of the "Silver Mountain," Keno Mountain, in the middle of the Yukon Territory, is only 200 miles to the Arctic Circle as the crow flies. It is thousands of miles, however, to the world's metropolises.

Although the distant view is veiled by fog, there is still much of interest to be seen close by: a beaver has built his dam in the pond in the foreground (on the edge of Cassiar Highway).

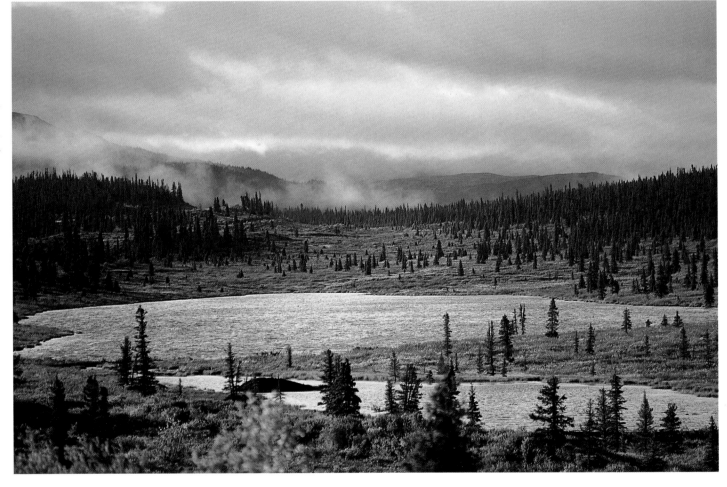

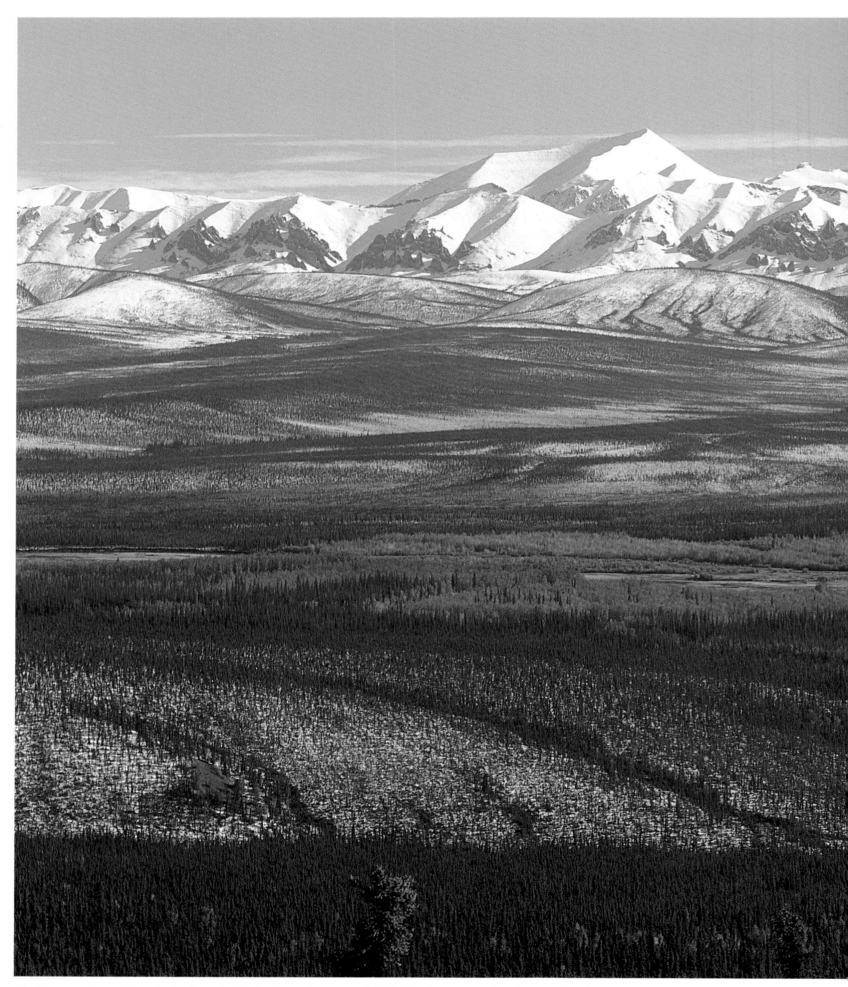

The journey north on Dempster Highway begins in the southern spur of the Ogilvie Mountains, already covered with snow in early autumn.

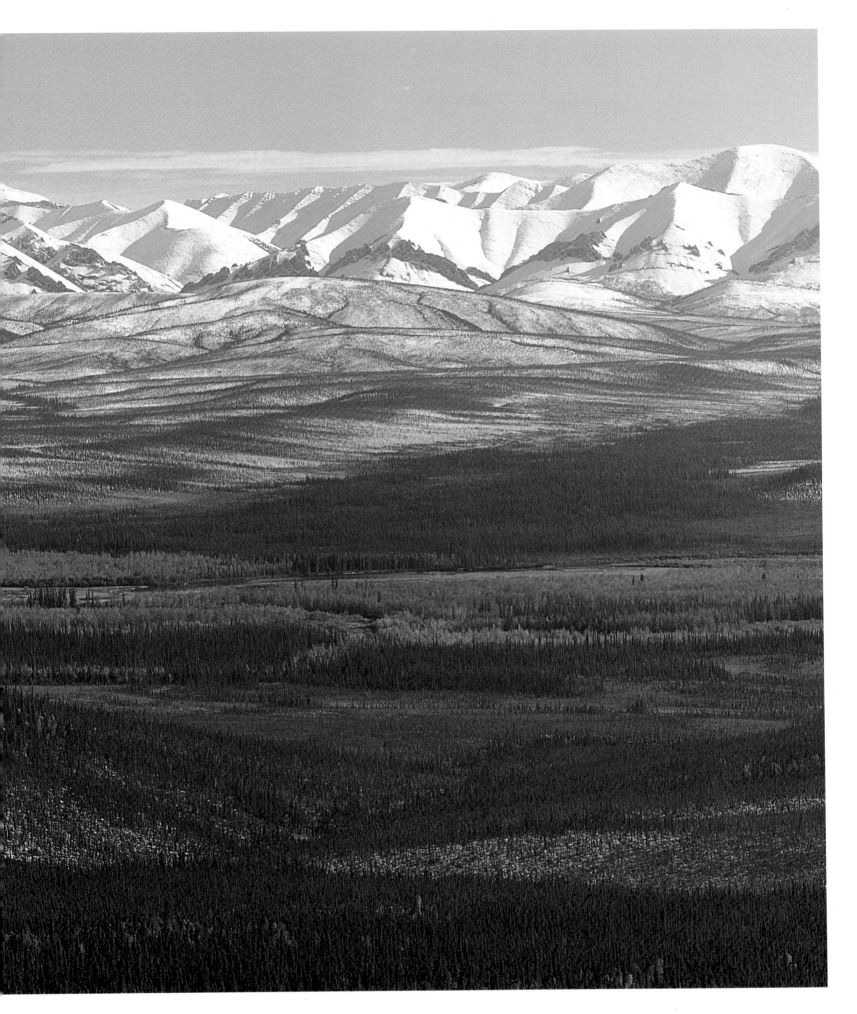

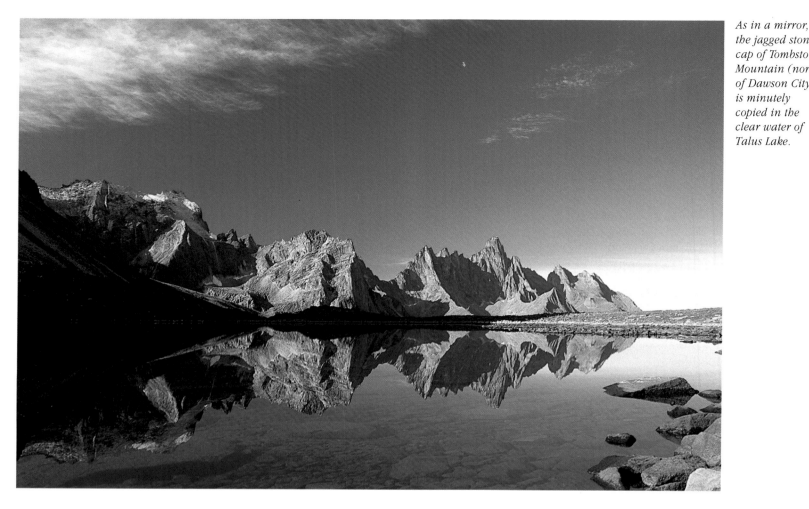

a new political awareness has asserted itself among its hereditary population. A new consciousness calls for self-determination and does not accept the values of the white world without criticism.

For centuries the question did not arise as to whom the north really "belonged." Nobody was concerned about land possession – certainly not the Inuit or Dene. In their view, they had lived for centuries as a part of the land. Nobody could "own" it. But for the white politicians in the south, the situation was clear: the land belonged to the state, for the few people wandering around nomadically could not own millions of square kilometers! Thus, official land contracts were never concluded between the Inuit and the British Crown or later with Canada.

It was not until the 1920s that political opinions began to change. Lawyers and civil rights activists from among their own ranks were now speaking up for the Inuit and the Dene. The Canadian government had to admit that they had not considered the rights of its Native inhabitants. At the beginning of the 1990s, Canada entered into long contract negotiations which recognized the claims of the Native Peoples. The Indians of the Yukon Territory and the Inuvialuit of the western Arctic received land, money and hunting rights as compensation. The Dene in the region around Great Slave Lake are currently negotiating for a self-administered tribal area.

The most spectacular results of the negotiations were the 1992 contracts concerning the independent territory of the Inuit in Canada. They call it Nunavut – Our Land. On April 1, 1999, a new country will be carved out of what are the Northwest Territories today, a land of two million square kilometers (780,000 square miles) in size – a fifth of Canada's surface. The new territory will not be a pure Inuit state, but it will be – populated at 80 percent by the Inuit – politically governed by them. In addition, the Inuit will have complete ownership rights of 18 percent of Nunavut's surface, which is 353,610 square kilometers (138,130 square miles), as well as hunting and fishing rights for the entire territory.

Nunavut will not "belong" to the Inuit, but they will determine the land planning, ecology, drilling for oil or gas, mining of natural resources, and all other day-to-day interests. For the people who for a long time were almost robbed of their cultural and political identity, disturbed by the effects of exploitation on their environment, this is a step towards self-responsibility, and the occasion for much hope for the future.

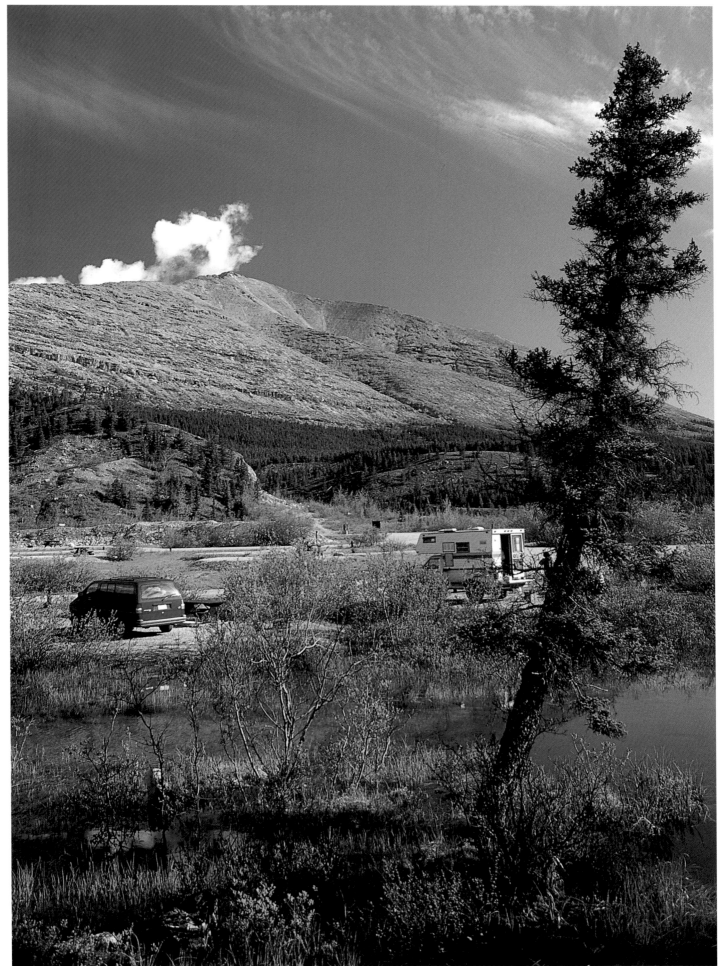

Tours in a camper allow for individual planning, for even up north there are simple camping grounds at regular distances along the highway.

CONTENTS

DATA · FACTS · FIGURES 62

MAP 63

INFORMATION 65

GETTING THERE 66

ENTRY INTO THE COUNTRY 66

TRAVELING IN THE ARCTIC 66

HIGHWAYS OF THE NORTH 67

CLIMATE 68

TRAVEL PERIODS AND CLOTHING 69

HEALTH CARE 69

ACCOMMODATION 70

NORTHERN CUISINE 70

HOLIDAYS AND FESTIVALS 70

SPORTING ACTIVITIES 71

SHOPPING AND SOUVENIRS 72

PHOTOGRAPHIC TIPS 72

GLOSSARY OF THE FAUNA 72

CANADA'S ARCTIC COLD STORAGE
ROOM – THE NORTH POLE 73

PLACES, LANDSCAPES AND
NATIONAL PARKS WORTH SEEING 76

IN AUYUITTUQ NATIONAL PARK 77

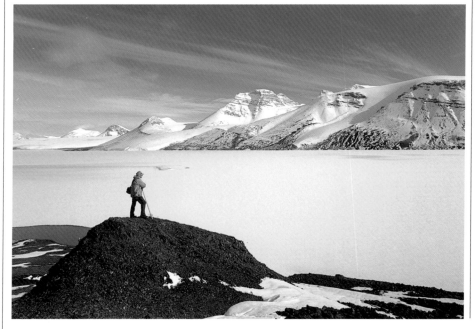

larger than Sweden. And Canada's north displays its massive dimensions in other superlatives. *Baffin Island*, the fifth-largest island in the world, has a surface area of a good 507,000 square kilometers (198,000 square miles). Some 138,000 square kilometers (54,000 square miles) of the Territories are covered with lakes, making up almost a tenth of the world's freshwater supply outside the polar cap. To the east, *Baffin Bay* and *Davis Strait* fix the limits of the Canadian Arctic with Greenland. In the west, the border with Alaska runs along the 141st degree longitude. In the north, the Arctic Ocean's pack ice stretches over the Arctic island world to the North Pole. It is only to the south that it is somewhat more difficult to demarcate the boundaries; although for administrative purpose the imaginary line of the 60th degree latitude is the southern border of the Territories, the transition zone between tundra and taiga reaches far into the south, as does the permafrost limit in central Canada. Large areas in the northern part of the provinces of Quebec, Manitoba, Saskatchewan, Alberta and British Columbia are as wild and un-developed as the Arctic landscapes to their north.

TOPOGRAPHY. The dominating land form in the central part of the Territories is the *Canadian Shield*. This two billion-year-old primeval landscape of Precambrian sedimentary rock, which was ground down by ice age glaciers, lies like a horseshoe around *Hudson Bay*. Hundreds

DATA · FACTS · FIGURES

SURFACE AREA AND LOCATION. Canada is the second-largest country in the world, after the Russian Republic. The northern territories comprise forty percent of Canada's approximately ten million-square-kilometer (3,900,000-square-mile) surface area. The *Northwest Territories* (NWT) have a surface area of 3.40 million square kilometers (1,300,000 square miles) – approximately ten times the size of Germany, for example – and extend 3,400 kilometers (2,100 miles) north from the 60th degree latitude to the northern tip of Ellesmere Island on the 82nd degree latitude. The *Yukon Territory*, bordering on the west, is substantially smaller, but with its 483,000 square kilometers (189,000 square miles) it is

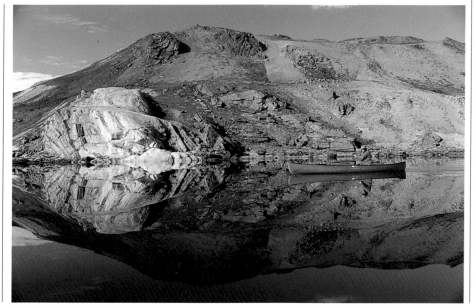

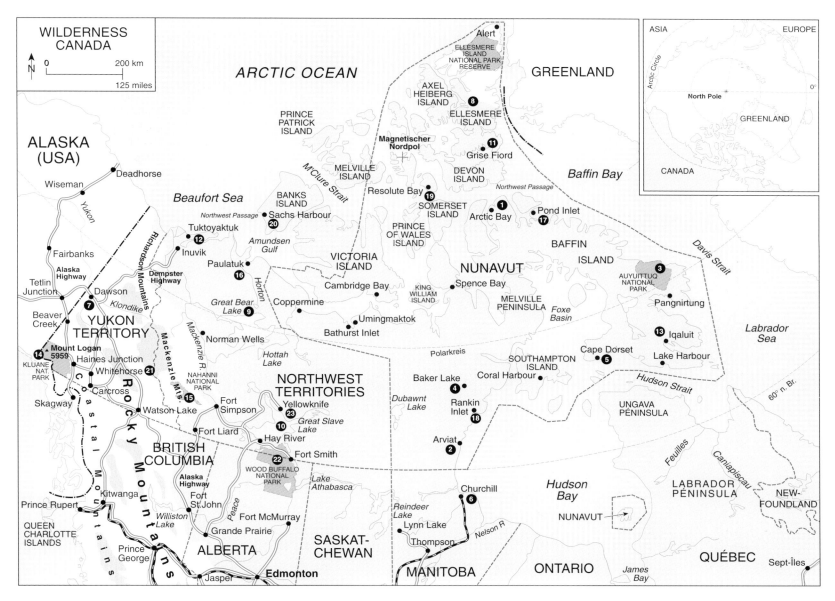

WILDERNESS CANADA

N
0 200 km
125 miles

ARCTIC OCEAN

ASIA EUROPE
North Pole 0°
CANADA
GREENLAND

Alert
ELLESMERE ISLAND NATIONAL PARK RESERVE
GREENLAND

AXEL HEIBERG ISLAND ❽
ELLESMERE ISLAND

PRINCE PATRICK ISLAND

Magnetischer Nordpol

❶❶ Grise Fiord
DEVON ISLAND
Baffin Bay

MELVILLE ISLAND
Resolute Bay ❶❾
SOMERSET ISLAND
Arctic Bay ❶
Pond Inlet ❶❼

ALASKA (USA)
Deadhorse
Wiseman

Beaufort Sea
BANKS ISLAND
Northwest Passage
Sachs Harbour ❷⓿
Tuktoyaktuk ❶❷
Inuvik

Amundsen Gulf
VICTORIA ISLAND
PRINCE OF WALES ISLAND
NUNAVUT
BAFFIN ISLAND

Davis Strait

AUYUITTUQ NATIONAL PARK ❸
Pangnirtung

Fairbanks
Alaska Highway
Tetlin Junction
Dawson ❼
Klondike
Beaver Creek
YUKON TERRITORY
Mount Logan 5959 ❶❹
KLUANE NAT. PARK
Haines Junction
Whitehorse ❷❶
Carcross
Skagway

Richardson Mountains
Dempster Highway
Paulatuk ❶❻
Horton
Great Bear Lake ❾
Norman Wells
Hottah Lake
NAHANNI NATIONAL PARK
Mackenzie Mts.
Mackenzie R.

Coppermine
Cambridge Bay
KING WILLIAM ISLAND
Umingmaktok
Bathurst Inlet
Polarkreis

Spence Bay
MELVILLE PENINSULA
Foxe Basin

Iqaluit ❶❸
Lake Harbour
Labrador Sea

Cape Dorset
❺

SOUTHAMPTON ISLAND
Coral Harbour
Hudson Strait
60° n. Br.

NORTHWEST TERRITORIES
Yellowknife ❷❸
Great Slave Lake
Fort Simpson
Fort Liard
Hay River ❶⓿
Fort Smith ❷❷
WOOD BUFFALO NATIONAL PARK

Dubawnt Lake
Baker Lake ❹
Rankin Inlet ❶❽
Arviat ❷

UNGAVA PENINSULA
Feuilles
Caniapiscau

COASTAL Mountains
ROCKY Mountains
Watson Lake ❶❺
Kitwanga
Prince Rupert
QUEEN CHARLOTTE ISLANDS
Prince George
ALBERTA
Fort St. John
Williston Lake
Grande Prairie
Fort McMurray
Jasper
Edmonton

BRITISH COLUMBIA
Alaska Highway
Peace
Lake Athabasca
SASKAT-CHEWAN
Reindeer Lake
Lynn Lake
Thompson
Nelson R.
Churchill ❻
MANITOBA

Hudson Bay
NUNAVUT →

ONTARIO
James Bay

LABRADOR PENINSULA
NEW-FOUNDLAND
QUÉBEC
Sept-Îles

Ellesmere Island: Icy winterscape on frozen Emma Fjord (top left).

Under way on Soper Lake in Kataklinik Provincial Park on the southern end of Baffin Island (left).

The deeply fissured rocks of Tombstone Range in the Yukon tower up to the blue sky (right).

of thousands of lakes and slightly wavy granite hill brows are everywhere evident. Northeast of these, heavily glaciered mountains tower over 2,500 meters (8,100 feet) on Baffin Island. West of the Canadian Shield are extensive prairies, the continuation of the great American prairies in the south. Here the *Mackenzie River* system flows, irrigating an area of 1.8 million square kilometers (703,000 square miles). With its longest headwater, the system is 4,240 kilometers (2,625 miles) in length. To the west, on the border with the Yukon Territory, are the *Richardson* and *Mackenzie Mountains*, the foothills of the North American Cordillera. The largest part of the Yukon Territory is mountainous and culminates in the extreme west in the highest elevation in the entire country. *Mount*

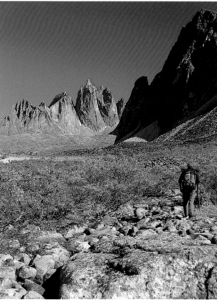

Logan in the St. Elias Range, Canada's highest mountain, rises 5,959 meters (19,400 feet). In the far north stretches the Arctic Archipelago, a labyrinth of tundra-covered islands, with tremendous ice-capped mountain ranges on *Axel Heiberg Island* and *Ellesmere Island.*

POPULATION AND LANGUAGES. Just 90,000 inhabitants live in the Northwest Territories and in the Yukon, which corresponds to a population density of only 0.02 people per square kilometer (0.05 people per square mile). The land areas of the north are almost empty of people, for almost all the inhabitants live in the few cities and settlements: *Whitehorse* alone has 18,000 inhabitants, and *Yellowknife* has 15,000 inhabitants. The rest of the population is spread out in the seventy

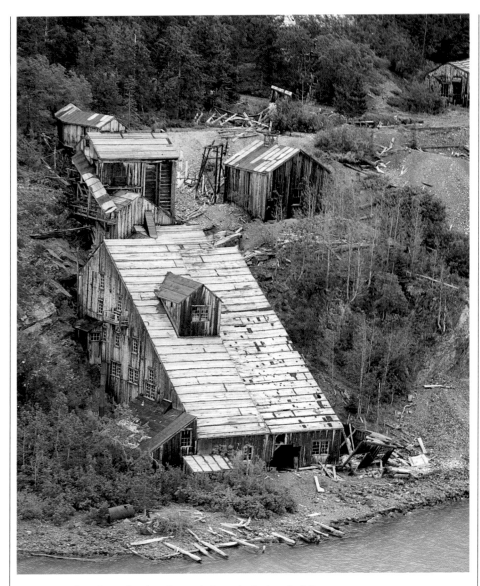

Many mines have been closed in the north due to lack of profitability.

in the Inuit villages on the Ungava Peninsula in northern Quebec and in the eastern Arctic. On the other hand, English is spoken everywhere from the Yukon Territory to Baffin Island. The languages and dialects of the Native Peoples can also be heard. The Inuit language – *Inuktitut* – is also an official language in the Northwest Territories. In addition, there are eight other Dene languages, spoken mostly in the region around Great Slave Lake and in the Yukon.

POLITICS AND ADMINISTRATION. Unlike the ten Canadian provinces in the south, the Yukon and the Northwest Territories are still administered officially by the federal government in Ottawa. An appointed *Commissioner* and his cabinet, called a *Council*, run the governmental business; for decades, the inhabitants of both regions had no voice whatsoever in the affairs. It was not until 1951 that elected members from the Northwest Territories were included in the council; since 1975, the council has been composed entirely of elected members. For some years, after the Inuit and Dene became aware of their political weight, the twenty-four-member council has been composed of a majority of freely elected representatives of the Native Peoples. The similarly structured administration of the Yukon Territory is

For gold in their hands, thousands risked and lost their lives in the north.

other settlements. Most of these places developed only in this century from trading posts and police outposts, around which the nomadic Native population settled.

Of the 63,000 inhabitants of the Northwest Territories, more than half are Native Peoples: the land north of the tree line is the domain of the *Inuit* (Eskimos), who today number around 21,000 members. In the taiga and the woods to the south live the Athapaskan-speaking tribes of the *Dene* with approximately 12,000 members. The Yukon Territory is home to some 7,000 Dene Indians – mostly scattered in small, traditional settlements. Most of the 50,000 whites in the north, a colorful mix of numerous immigrant generations, are concentrated in the larger towns.

Canada is officially a bilingual country, with English and French as the official languages. Although French is seldom heard in the northern region, it is spoken

Relics of long-gone days: abandoned tools of gold prospectors in the Yukon.

composed of a five-member *Cabinet*, appointed by an elected representation, the *legislative assembly*. The *Commissioner*, appointed by Ottawa, has only a limited voice here.

After years-long negotiations for land rights and political self-determination, the map of the Northwest Territories will

fundamentally change on April 1, 1999: the Inuit will obtain their own territory, some two million square kilometers (781,000 square miles), carved out of today's Northwest Territories. It is to be called Nunavut, Our Land, and the Inuit alone will determine the fate of their homeland. The Dene tribes are still negotiating with the central government in Ottawa about a similar settlement.

ECONOMY. Whaling and trapping were the first important sources of cash income in the Arctic region. But whales have not been hunted for a long time, and trapping, so important for the Native Peoples, has dropped sharply since the days of the Hudson's Bay Company as a result of pressure by nature conservationists. But many inhabitants of the Territories live by hunting, fishing and trapping. In the remote, smaller villages particularly, in which there are very few other sources of livelihood, many families improve the traditional menu with whatever the land provides. The Dene hunt *moose* and *caribou*, the Inuit of the coastal settlements pursue *seal, walrus, muskoxen,* and *caribou.* The economic development of the north began with the great Klondike gold rush of 1898, and gold is still prospected in the *Dawson City* area. The fact that rich natural resources could be found in the rocks of the Canadian Shield was not realized until the 1930s. Since then, great gold and diamond mines have been developed in *Yellowknife;* since 1974, lead, zinc and traces of silver have been mined in Nanisivik on the northern end of Baffin Island; and lead and zinc have been found on *Little Cornwallis Island.* In addition to this, there is considerable oil in the *Mackenzie Region* near Fort Norman and in the *Beaufort Sea,* where, however, no extraction is being carried out currently. But more important than all these industries, especially for smaller places, are tourism and arts and crafts. Inuit engravings and sculptures have made a world-wide name for themselves, and guiding of adventure tourists, anglers and hunters offers many Inuit and Dene an additional income.

TIME ZONES. Because of their enormous east-west extent, both of Canada's northern territories are involved in almost all the country's time zones. There are five time zones in all: from the *Atlantic Time*

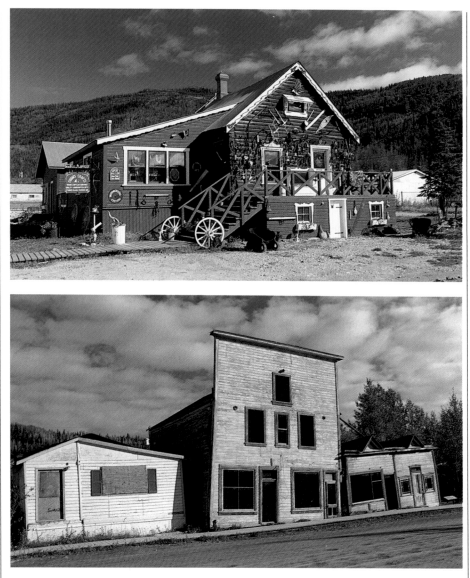

Still a legend – Dawson City, once Eldorado, today a much visited museum city.

Zone on the east coast of Baffin Island (CET minus 5 hours) to *Eastern Time* around the Hudson Bay area, *Central Time* in central Arctic, *Mountain Time* in the entire western part of the Northwest Territories to *Pacific Time Zone* (CET minus 9 hours) in the Yukon Territory on the border to Alaska. As in southern Canada, the clock is set forward one hour at the beginning of April to the end of October – even though in any case in the north it is bright around the clock.

INFORMATION

INFORMATION. Maps, information about accommodations and suppliers of equipment for excursions, and answers to individual questions can be obtained directly from the tourism offices of the Territories: *Department of Economic Development and Tourism,* Box 13 20, Yellowknife, NWT, Canada X1A 2L9, Tel: (403) 873 – 72 00, Fax: (403) 873 – 02 94; *Tourism Yukon* P. O. Box 27 03, Whitehorse, Yukon, Canada Y1A 2C6, Tel: (403) 667 – 53 40, Fax: (403) 667 – 26 34.

FURTHER INFORMATION. Local travel agencies usually cannot provide very much in the way of offers pertaining to the Canadian Arctic; this includes camper and rental car tours or accompanied tours in the Yukon Territory. The Northwest Territories always lose out. But there are special promoters, who, in addition to organizing individual Yukon journeys, also offer trips to other parts of the Arctic.

CANADIAN PROMOTERS. A tour by rental car or camper can be achieved without difficulty. But, at least for the first trip in the wilderness, it is wise to turn to an experienced equipment supplier who knows the region and who will take care of the equipment. Here are a few addresses:

Adventure Canada, 2426 Goodison Ave., Mississauga, Ont., Canada L5B 2A1, Tel. and Fax: (905) 270 – 83 43, offers cultural and nature tours in the entire Northwest Territories, expeditions to the High Arctic and hiking in Auyuiyyuq Park.

CANADIAN RIVER EXPEDITIONS # 37 – 35214 W. 16th Ave., Vancouver, B.C., Canada, Tel: (604) 738 – 44 49, Fax: (604) 736 – 55 26, organizes raft tours on the Kluane National Park rivers.

High Arctic International Explorer Services, Box 200, Resolute Bay, NWT, Canada, X0A 0V0, Tel: (819) 252 – 38 75, Fax: (819) 252 – 37 66, has supplied for decades all important expeditions to the Arctic Archipelago, including tour planning and equipment.

Ruby Range Adventures, Box 48 20, Whitehorse, Yukon, Canada Y1A 4N6 Tel: (403) 667 – 77 90, Fax: (403) 667 – 63 03, maintains a base lodge on Kluane Lake and is a suitable starting point for canoe, hiking and angling tours.

Simpson Air, Box 260, Fort Simpson, NWT, Canada, X0E 0N0, Tel: (403) 695 – 25 05, Fax: (403) 695 – 29 25, is a reliable charter aircraft company for tours and sightseeing flights in Nahanni National Park.

Nahanni River Adventures, P.O. Box 48 69, Whitehorse, Yukon, Canada, Y1A 4N6, Tel: (403) 668 – 31 80, Fax: (403) 668 – 30 56, offers canoe and rubber dinghy tours on Nahanni River.

MAPS. Detailed topographical maps for self-organized hiking and canoe trips can be ordered at: *Canada Map Office, Energy, Mines and Resources*, 615 Booth St., Ottawa, Ont., Canada, K1A OE9.

GETTING THERE

Canada's international airports in the south can be reached from most of the world by fast scheduled flights. During the summer season, there are also charter flights to Toronto and Vancouver. Commercial airlines sometimes offer substantially reduced special rates (Holiday Fare, Maple Leaf Special); however, it is necessary to stay for a certain number of days and a fee is charged for change of reservation or cancellation. During the high summer season, it is wise to book as early as possible.

The trans-Atlantic flight is, however, only the first stage on the way to the goal of the north. There are scheduled flights with *Air Canada* and *Canadian Airlines* – often jointly with smaller partner airlines – from all large Canadian cities to the destinations in the north. The most important departure points for an Arctic destination are Montreal and Ottawa in the country's east and Winnipeg and Edmonton in the west. From here, there are good connections to Iqaluit, Yellowknife, Inuvik and Whitehorse, the most

Here I reign and tolerate no trespassers! Nanuk the polar bear.

important air traffic junction within the Territories. Because northern flights booked on the spot are relatively expensive, it is usually worthwhile, if possible, to book the flights in Europe, along with the trans-Atlantic flight. The *round-trip tickets* (coupon air passes) proposed by *Air Canada* and *Canadian Airlines*, valid on the most important routes in the Territories, offer a comparatively inexpensive method of putting together an air trip with several stops in the north.

ENTRY INTO THE COUNTRY

ENTRANCE REGULATIONS. Tourists should check with the Canadian Consulate in their country of residence before leaving to determine the necessity of a visa. The tourist should be able to prove at the border that he has picture identification plus enough travel cash and a return ticket, should the immigration officer ask for them. Caution at customs: Fresh provisions such as sausages or fruit may not be brought into Canada. The same applies to plants. Importation of guns for hunting (no hand guns) with gun permits, as well as fishing gear, is duty free and allowed.

CURRENCY. The currency used is the Canadian dollar (CAN-$). Due to the fact that exchange offices are virtually unknown outside of the large international airports in the south, it is recommended that traveling money be carried in travelers' checks (made out in Canadian dollars), with a smaller amount of Canadian dollars in cash. One of the common credit cards is also very helpful.

TRAVELING IN THE ARCTIC

AIRPLANE. Even the most diminutive town in the north has its own airport, for the plane is often the only method of transportation through the rugged terrain – and almost as common as traveling by bus in Europe. *Air Canada* with its partner airline *NWT Air*, and *Canadian Airlines* with its partners *Canadian North* and *Calm Air*, as well as some other regional companies such as *First Air*, *Air Baffin*, *Air North* and *Air Inuit*, offer scheduled flights to the larger as well as to many of the smaller settlements.

Bush pilots will fly seaplane passengers wishing to make individual expeditions into the hinterland – to the upper reaches of a river, for example – along with their equipment, canoe or kayak, and pick them up again at a previously determined time and place. Air taxis and charter companies can be found in all the more important places: Iqaluit, Rankin Inlet, Dawson, Whitehorse, Inuvik, Yellowknife, Fort Simpson, Hay River and others. As a rule of thumb, the farther north the trip and the farther away from roads, the more expensive will be the charter flight. As touring on one's own can be quite costly in the High Arctic, group tours are recommended for such traveling. The distances are immense – and one does wish, after all, to be picked up again sometime, so the charter price automatically doubles.

A camp on a remote lake, a campfire far from any human settlement, a glimpse of the midnight sun over the Mackenzie River – dreams of the wilderness attract, and they do not necessarily have to be paid for with a costly expedition. The dream can be realized more easily and cheaply. A circular tour with a camper or rental car is the most sensible way of sightseeing in the Yukon Territory and the western part of the Northwest Territories, despite a limited – yet all-weather – road network.

There is a choice of two main routes: the legendary Alaska Highway in the Yukon Territory, and the Mackenzie Highway, which runs almost 1,600 kilometers (1,000 miles) from Edmonton via Grimshaw far up to Yellowknife. A network of smaller gravel roads joins the wilderness to the west bank of Great Slave Lake. Branch roads lead into Wood Buffalo National Park, on the southern bank of the lake, to Fort Resolution and along the Mackenzie River. The road to Wrigley via Fort Simpson was not completed until 1994. And finally there is Liard Highway, which runs east of Nahanni National Park from Fort Simpson to Fort Nelson and turns back again to the south, thus allowing a circular tour of the Northwest Territories. Much more famous – and much more varied – than the Mackenzie route is the Alaska Highway, built as a military road in the Second World War and still the only land connection between Canada and Alaska. It is 1,470 kilometers (920 miles), through tremendous

HIGHWAYS OF THE NORTH

Driving a car is becoming increasingly a matter of course in Canada's north. More and more highways are being developed on formerly inaccessible land.

On the road, alone or in columns of vehicles: the highways beckon to be "discovered."

river valleys and over untouched mountain ranges, from Dawson City in British Columbia up to Whitehorse; from there, it is another 1,000 kilometers (625 miles) to Fairbanks in Alaska. A week at least should be planned for the Yukon Territory in order to discover the most important side roads, such as the Klondike

Highway to Dawson City, and Highway 2 from Whitehorse via the White Pass to the old Alaskan gold fields and the port of Skagway. Those wishing to save themselves the long way back can return south via the Alaska State Ferry through the islands. The only alternate route for the return is Cassiar Highway, a still little known but very worthwhile stretch along the Coast Mountains.

Today, the formerly notorious Alaska Highway is paved in parts and straightened. The other important routes as well are either all-weather roads or are at least well reinforced. Although there are potholes here and there, and stretches of gravel road in between, the routes are on the whole quite civilized: at least every 100 kilometers (63 miles), there is a gas station and a little lodge or village. Expedition equipment is no longer necessary. Where is the adventure in all this? Have no fear, the journey along the highway will bring copious amounts of wilderness experiences. The lonely land is always in the field of vision and traffic is scarce.

In addition, there are thoroughly "wild" by-routes to discover. One such is the Dempster Highway, the only road in Canada north of the Arctic Circle. Seven hundred grandiose kilometers (440 miles) lead the tourist from Dawson City north over wind-whipped mountain ranges down into the Mackenzie Delta to Inuvik. There are only two Dene villages and a gas station on the entire stretch. And wilderness is all around.

Karl Teuschl

TRAIN. Only one train line with passenger service even remotely approaches the Arctic: the Canadian *VIA Rail* train company runs a train three times a week from Winnipeg to Churchill on Hudson Bay – a trip of about 35 hours. Also worth mentioning is the historical narrow gauge *White Pass & Yukon Route*, built around 1900 at the time of the Gold Rush, and which today undertakes excursion trips from the harbor of Skagway in Alaska over the *White Pass* to *Log Cabin;* from here, bus connections to Whitehorse are available.

BUS. There are only a few bus connections on the western Arctic road network. From

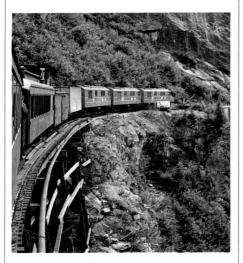

A steep climb to White Pass on the historical White Pass & Yukon Route.

Edmonton, overland busses of the *Greyhound Lines of Canada* run to Hay River (NWT) and over the Alaska Highway to Whitehorse (YT). From here, however – at most once a day – there are connections with various smaller bus lines: *Frontier Coachlines* serves the Hay River-Yellowknife stretch, *Alaskon Express* runs the Whitehorse-Haines Junction-Fairbanks/Alaska route, and *Nordline Coaches* travel on the Whitehorse-Dawson City stretch. Twice a week in summer a bus of the *Arctic Tour Company* goes from Dawson City to Inuvik. Several charter companies also offer guided round trips.

RENTAL CARS AND CAMPERS. Companies renting cars and campers are available in Whitehorse and Yellowknife. It is often wiser and less expensive, however, to rent a vehicle beforehand in Edmonton or

Calgary, and then to drive into the north via the highway – just the drive through the isolated northern woods is an experience. The *Alaska Highway*, completed in 1942 by the American military, is now mostly asphalted; many of the other roads are gravel roads, but usually in quite good condition. A fourwheel drive vehicle is desirable for steep, rutted sections with soft (or no) shoulders. Service stations can usually be found at distances of 100 to 150 kilometers (63 to 95 miles).

SHIP. Although the north is completely surrounded by water, sightseeing by ship is quite limited because of the dangers caused by drift ice and pack ice. Yet every few years, a cruise ship attempts to conquer the Northwest Passage – with no guarantees. Bookings and information can be obtained from all travel agencies dealing in cruises. There is no regular line for the Arctic waters. From the coast of Labrador, in summer only, there is a ferry from the island of Newfoundland to Nain in northern Labrador. This highly recommended one-week tour does not actually run through the real Arctc, but Labrador's treeless coast and the icebergs drifting by leave nothing to be desired. Information and reservations at *Marine Atlantic*, P. O. Box 250, North Sydney, Nova Scotia, Tel: (902) 795 – 57 00, Fax: (902) 564 – 74 80.

CLIMATE

The gigantic landmass of the approximately 4,000-kilometer- (2,500-mile-) wide continent causes a very extreme, very dry continental climate. The surrounding seas exercise a moderating influence only on the periphery. The massive western cordillera, up to 6000 meters (19,500 feet) high, largely screens the country's interior from moist air and Pacific storms.

Especially extreme are the temperatures in the west Arctic Mackenzie Valley and in the Yukon Territory: bitterly cold winters and amazingly hot, sunny summers with long periods of pleasant weather are the rule here. Near Kluane Lake in the Yukon, the coldest temperature ever recorded in Canada was registered in February 1947: *minus 63 degrees Celsius (– 81.4 degrees Fahrenheit).* In summer, however, the average temperature (due not least to the long hours of sunlight) is approximately 16 degrees Celsius (61 degrees Fahrenheit); at noon the temperature can often

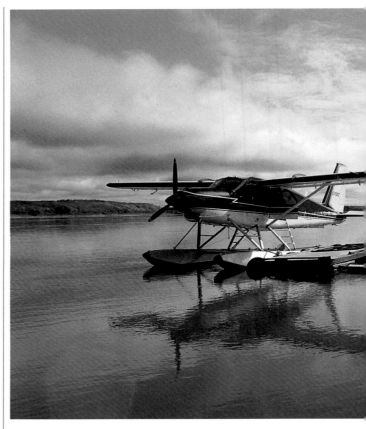

Indispensable in the north: a seaplane and bush pilot (top).

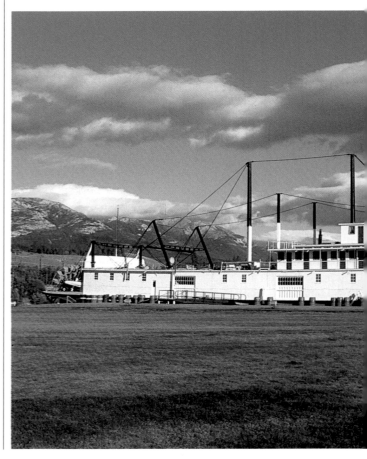

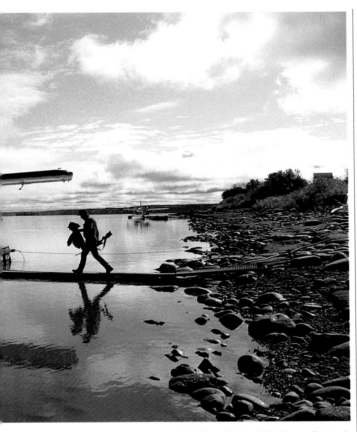

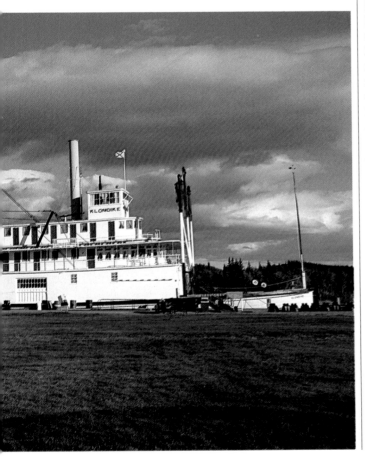

Museum steamer "S. S. Klondike" in Whitehorse (bottom).

reach 25 or even 30 degrees Celsius (77 to 86 degrees Fahrenheit). Precipitation in this region is about 300 millimeters (12 inches) per year; thus the snowfall in winter is usually only between one and two meters (3.25 and 6.50 feet). Only the mountain regions in the west have more precipitation from the Pacific, which accounts for the heavy glaciation in Kluane National Park.

In the central part of the Northwest Territories and around Hudson Bay, these extremes are rarer. Summers are somewhat cooler (average temperature 11 degrees Celsius, (52 degrees Fahrenheit); the winters, however, are now only slightly warmer. Here there are no mountain ranges to hinder the advance of the Arctic air to the south. As a consequence, the temperature at Baker Lake in January may be minus 33 degrees Celsius (– 27 degrees Fahrenheit), and the thermometer can read 25 degrees Celsius (77 degrees Fahrenheit) on summer days. The Arctic Archipelago is, after all, protected from extreme low temperatures by the surrounding sea, despite the fact that the sea is covered with almost year-round pack ice; it does not warm up even in midsummer. The average temperature here is only four degrees Celsius (40 degrees Fahrenheit). With precipitation of less than 200 millimeters (8 inches), this region is an Arctic desert, in parts with no vegetation. Only the extreme south-eastern parts of the Canadian Arctic, the Baffin Island and Labrador regions, are somewhat more moist and of a milder climate, due to the proximity of the north Atlantic.

TRAVEL PERIODS AND CLOTHING

Depending on the latitude, the Arctic summer lasts only six to ten weeks, from mid-June to the beginning of September, but good weather is not rare. Although a circular tour in the Yukon Territory and on the western roads of the Northwest Territories may be undertaken at the beginning of June, the best time to travel is mid-July to the end of August. In August, the nuisance caused by the mosquitoes eases up a little. The short autumn can be especially lovely (mid-August to mid-September, depending on the region), when the tundra changes color to red-gold tints and the mountains

are lightly powdered with new snow. Trips to the High Arctic should only be planned for the high summer months of July or August, however – or in April, when it is light for a long time during the day and the snow can still bear a load. For winter tours, extremely warm winter clothing and equipment are a matter of course; wind-repellent clothing is especially necessary, as temperatures are often felt to be much lower because of the dry, icy wind. This also applies, to a lesser degree, for summer tours in the northern islands. Inland, however, in the Yukon and Mackenzie regions, long underwear can be left at home during the summer; only in the evening is a sweater needed.

This is part of daily life in northern Canada: driving a car on an ice track.

Sturdy, water-repellant hiking boots are as important a part of the luggage as sun screen. Despite the occasionally very high temperatures, T-shirts and shorts will not be suitable, for the infamous mosquitoes and black flies plunge onto every exposed little piece of skin. Loose, airy clothing and thick lumberjack shirts – but not tight jeans – are the best protection. Judging by previous experience, the insect repellents offered in Canada, "Off" and "Cutter," work quite well.

HEALTH CARE

Medical care is assured in this gigantic region, but it is not always quickly attainable. Only the larger towns, such as Iqaluit, Yellowknife and Whitehorse, have a hospital and established doctors. In the more remote settlements there is usually a clinic and a trained nurse who treats

minor injuries and who has medicines on hand. In an emergency, one can apply to the nearest Royal Canadian Mounted Police (RCMP) station, where the "Mounties" will assess the situation. For more serious operations, patients are flown to clinics in the south. Foreigners are automatically considered as private patients. It is therefore urgently recommended that the tourist obtain travel health insurance. A rescue helicopter from the hinterland can quickly run up a bill of several thousand dollars. An emergency medical kit is indispensable for canoe and hiking trips and expeditions in the wilderness.

ACCOMMODATION

HOTELS. Only in the larger cities, such as Iqaluit, Dawson, and Yellowknife, and in the towns along the highway in the western part of the Yukon and the Northwest Territories, is there a fairly large choice of hotels and motels; these are not luxury accommodations, but they are thoroughly clean and of an up-market standard. In the areas of the north accessible only by airplane, the offer is usually reduced to just one accommodation per town, not especially cozy, but the traveler is happy to have any place at all – in the high season, often only after a somewhat lengthy advance booking. In some villages, bed & breakfast possibilities are now offered. In other places without hotels the tourist pitches his tent at the edge of town, or, if on an organized tour, is put up by local guides in private homes.

CAMPING. Needless to say, marked camping grounds with camper sites are found along the highways; these are well-appointed private grounds with electricity and water connections. Unsupervised camping is not prohibited, and in smaller Inuit towns the wilderness is often the only possibility. Close to town, it is advisable to inquire as to whether there are special areas for campers. In the national parks, special regulations are often in force as to the locality and the manner of camping, in order not to overload nature. Information is available in the Visitors' Centers.

NATURAL LODGES. The so-called "Naturalist" or "Adventure Lodges" afford an unusual opportunity of combining comfortable

accommodation in the wilderness with a nature experience. These remote wilderness hotels of five to ten rooms can usually be reached only by plane. In the area, animals can be observed, canoe trips and hikes undertaken – and in the evening, the traveler returns to the care of the comfortable lodge. The committed owners, well-versed in nature, run their houses with consideration for the ecology

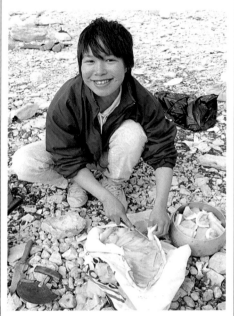

The fresh catch is skillfully carved up, to be made into traditional dishes.

Provision is made in good time for winter reserves: fish drying in the air

and know their area very well. A few examples: *Bathurst Inlet Lodge*, P. O. Box 320, Yellowknife, NWT, Canada X1A 2N6, Tel: (403) 873 – 25 95, Fax: (403) 920 – 42 63 lies far north on the Arctic coast. *Old-squaw Lodge*, Bag Service 2711, Whitehorse, YT, Canada Y1A 4K8, Tel. and Fax: (403) 668 – 67 32 offers animal observation in the Mackenzie Mountains. *Seal River Lodge*, Box 520, Churchill, Canada, R0B 0E0, Tel: (204) 675 – 26 29, Fax: (204) 675 – 28 52, on the banks of

Hudson Bay, is ideal for observing beluga whales and, in October, the amphibious polar bears as they gather in groups here.

NORTHERN CUISINE

"Normal" Canadian food has made its way to the north: steaks, potatoes, noodles and more. Fish from local waters as well is often on the menu.

In smaller towns or on the occasion of festivals, the traditional specialities, often very high in fat, of the Inuit and Dene are served. In the south, moose steak and wild goose are on the menu. *Pemmican*, known since the days of the trappers, is composed of dried, pounded meat, mixed with fat and berries. A traditional accompaniment is *bannock*, a biscuit batter drop-cooked in hot fat, a staple in the diets of early settlers. Farther north, stews made with caribou or muskoxen, rabbit meat, wild ducks and geese are also available. And in an Inuit village along the coast, it might be possible, with a little luck, to sample seal, or perhaps *muktuk*, whale flesh with its adhering blubber, cut into strips – which requires some getting used to for the non-initiated.

HOLIDAYS AND FESTIVALS

From time immemorial, the Inuit and the Dene have celebrated special occasions, such as the completion of a successful hunt, the start of spring or ice break-up. The traditions have been maintained, but the festivals are now celebrated on certain weekends. Thus, Yellowknife celebrates the *Caribou Carnival* at the end of March, Inuvik the *Muskrat Jamboree* at the beginning of April, and Iqaluit the *Toonik Thyme*. Midsummer Eve is also celebrated with festivities in many northern towns, such as Dawson City and Inuvik. Nanisivik yearly organizes the *Midnight Sun Marathon* at the end of June, the northernmost marathon in the world. And on August 17 Dawson City celebrates the discovery of gold in the Klondike with parades and gold panning contests – one of the biggest festivals in the entire north.

Sporting contests are almost always de rigueur, for dexterity and strength are a part of the Inuit life. Almost every type of contest is held, from snowmobile, boat and foot races to tea-making and igloo-building competitions.

Canadian public holidays as well as church holidays play only a subordinate role. Apart from the fact that banks and offices in the larger towns are closed, everyday life follows its usual course.

SPORTING ACTIVITIES

ANGLING. The countless lakes and rivers of the northern Territories, especially towards the south, have rich booty in store for the disciples of St. Peter. The most important fish species are rainbow and lake trout, walleyed pike, northern pike, and – ever popular with sporting anglers – Arctic char, a type of salmon that can weigh as much as fifteen kilograms (33 pounds). The angler is required to have a sport fishing license before trying his luck. The license can be obtained on the spot in lodges and sporting goods stores. Here, one can also obtain

In the middle of dense bush lies this "cache" (supply house) of a Canadian trapper.

brochures with the regulations for sport fishing in the territory concerned.

In the national parks, a special license, valid for all national parks, is required; this license is available from the park authorities. On Great Bear Lake and Great Slave Lake, there are special fishing lodges offering guided angling tours. Even without much previous experience, the would-be angler, during a canoe trip or a cicular tour with the camper, can improve the menu with fresh fish.

CANOE AND KAYAK TRIPS. The north's water courses were the travel routes of the Native inhabitants as well as the routes by which the white discoverers and fur traders developed the country. A canoe or kayak trip is thus a journey following the

tracks of the pioneers. At least for the first trip to the north, the tourist should join a guided tour, such as those offered by numerous promoters (see page 66 concerning this). The wide, flowing *Yukon River* between Whitehorse and Dawson City is considered the most popular canoe route in the north; it is relatively easy as well, as is a canoe trip on *Slave River*. More difficult is a canoe, rubber dinghy

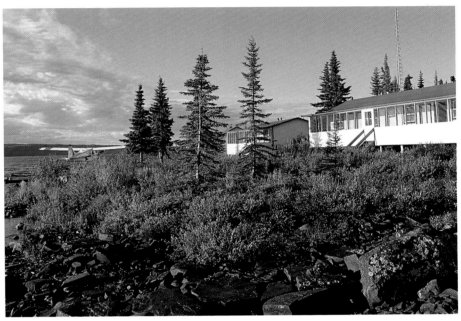

On Great Slave Lake, comfortable fishing lodges and rich fishing grounds are an attraction.

or kayak tour on *South Nahanni River* through the dramatic gullies of the national park of the same name. Numerous other rivers, such as the *Horton* and

A worthwhile catch: two magnificent specimens.

Coppermine Rivers in the remote interior of the Northwest Territories, await adventurous wilderness tourists.

Sea kayaking along the Arctic Ocean coast, off Baffin Island or Ellesmere Island, for example, has something of an expedition about it, and should only be undertaken after full preparation – a sport for real adventurers. Organized rafting tours with great rubber dinghies, such as those on the *Tatshenhini River* or *Alsek River* in Kluane National Park, have also become very popular in recent years.

HIKING. In the extensive tundra and taiga areas of the central Arctic, hiking is not often possible, as in summer the permafrost turns into a swamp. Only in the mountain regions of the west, on Baffin Island and on the tundra of the Arctic islands, can the hiker get around more or less successfully – even without marked paths. But hiking paths in the entire north are quite rare, for distances between towns are just too great. Yet there are a few touring possibilities: three- to five-day hikes over *Chilkoot Trail*, which gained fame in gold prospecting days, and hikes through *Kluane National Park* in the Yukon Territory can be recommended. Tours along *Canol Road*, which have something of an expedition about them, presuppose the appropriate experience. The most famous hiking path in the Northwest Territories is the route over

Pangnirtung Pass in *Auyuittuq National Park*. Promoters also offer this tour.

HUNTING. Trophy hunts for polar bears, muskoxen, caribou, mountain sheep and grizzlies are permissible for non-Native hunters only with licensed outfitters, whose task it is to organize the hunt and the equipment. A hunting license is required. Firearms are forbidden in national parks and other conservation areas.

with a pair of mukluks, boots made of caribou and seal fur with watertight seams, or a wonderfully light, very warm scarf or a pullover of muskox wool, a high-quality fibre called quiviut? Scrimshaw, tiny etchings on the teeth and bones of sperm whales and on walrus tusks, is a special Canadian artwork. But be aware that the export of these miniature pieces of art requires authorization, as does the export of polar bear skins.

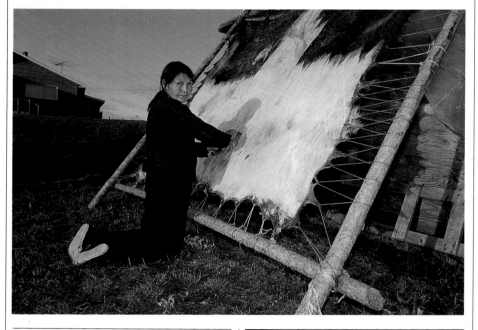

SHOPPING AND SOUVENIRS

Equipment as well as food for a wilderness tour should be bought in the southern metropolises, because of the advantageous prices and the wider choice. The buying of souvenirs, however, is quite problem-free, for arts and crafts flourish. The Dene make parkas, attractive leather jackets and moccasins with decorations of moose hair, colored beads and porcupine quills. The soapstone and horn carvings and the engravings from Cape Dorset, Baker Lake, Holman and Pangnirtung are equally famous. These items can be purchased directly from the artist or in an artists' co-op in the settlement itself, as well as in the often quite good art galleries of the larger cities, such as "Arctic Images" in Whitehorse or "Northern Trading Post" in Yellowknife.

In addition, the Inuit make all sorts of interesting utility articles. How about a traditional, semi-circular Eskimo knife,

Cleaning a moose hide (top); a hide blanket, fashioned by Inuit in a chessboard pattern (right); sandstone figures (center); an "ulu," the practical knife of the Inuit woman (bottom).

PHOTOGRAPHIC TIPS

The north's clear light and the dust-free air usually ensure brilliant pictures, but in high summer at noon, it also ensures a very hard light. An ultra-violet or skylight filter is therefore absolutely necessary. For shots with wide, cloud-covered skies, a polarization filter is recommended, which can strengthen the dramatic atmosphere. Recommended are a wide-angle lens (20 – 24 mm), a macro lens for close-ups of tiny tundra flowers and other details, as well as one or two telephoto lenses or a zoom lens: approximately 100 mm for portrait shots as well as 200 mm to 600 mm focal length for animal shots. Particularly on the islands of the High Arctic, where the wind is often strong, a sturdy, heavy tripod for the camera, as well as for the video recorder, is highly recommended. Sufficient film should also be brought along, for well-stocked photographic shops in the entire north can be found only in Whitehorse, Dawson,

Yellowknife and Iqaluit. A winter or spring trip requires special preparations: enough extra batteries should be brought along, and perhaps for long tours battery packs which hang from the exterior of the camera, and which are worn on the body, thereby keeping them warm.

GLOSSARY OF THE FAUNA

The sparse, in parts desert-like Canadian north is the habitat of an amazingly varied animal world. Numerous sea mammals inhabit the Arctic waters, gigantic caribou herds roam the tundra, and hundreds of thousands of migratory birds – geese, ducks and all sorts of

I n 1978, a Mister Wheeler promised the good people of Resolute that Playboy Bunnies and their boss Hugh Hefner would come. But then some older people with no swinging ambitions climbed out of the airplane. The 160 Eskimos of the little Arctic neck of the woods had not taken the loud-mouthed egocentric from Las Vegas seriously anyway. But in fact the showman had assembled the first tourist group in the world to make a trip to the North Pole.

A good seventy years after Peary, traveling with his dog-sled, vanquished the Pole, clicking Kodak cameras introduced tourism to this part of the world. The two first attempts, however, went wrong. The weather was not co-operative; the Pole addicts were consequently obliged to fly back to base camp.

The third approach was successful. The plane hardly landed when Wheeler darted behind an ice floe, reappearing dressed as Santa Claus to greet the guests – for, according to American tradition, Santa Claus lives at the North Pole.

Since that time, North Pole all-inclusive tours have become routine for the in-habitants of Resolute, for they had pre-viously experienced all sorts of polar adventures. There was a group of ama-teur radio enthusiasts who wanted to broadcast from the 0 – 360 longitude position – in vain. Parachutists planned to reach the last few feet to the Pole by

CANADA'S ARCTIC COLD STORAGE ROOM

The North Pole

Despite freezing temperatures, the North Pole lures tourists and characters – even if it is only for a very short trip.

Resolute Bay is the point of departure for adventurous North Pole expeditions.

their own force of gravity – but weather caused them to land somewhere on the 80th degree. Another group, five bal-loonists who were able to disembark their hot air apparatus exactly on target, recently were the first to take to the skies

in this way at the Pole, before hastening away to more hospitable climes by plane. A group from a Japanese univer-sity, also in 1978, bought 170 sled-dogs in Greenland on their way to the Canadian Arctic, and had the dogs flown in a transport aircraft to the Arctic military post of Alert in the north of Ellesmere Island. Due to the fact that the dogs had not been properly loaded, during the unusual journey they had fought to the death among themselves; only sixty-five dogs survived. But the Japanese set out anyway – more or less in a contest against one single person. Their fellow countryman, Naomi Uemura, had set out from Resolute with the firm intention of being the first to go solo to the Pole. Naomi Uemura, who with his modest ways and adventurous courage had won the hearts of the Inuit, arrived just five days after his compatriots. All the head-lines were for him and his solitary march, which he continued over the ice to Greenland. Resolute could tell of many bizarre North Pole attempts, from the first search for a polar route, to the efforts of the aristocratic couple, Sir Ranulph Twistelton-Wyheham-Fiennes and Lady Virginia, who headed for the Pole by motorboat with mounted pon-toons. At the first ice hole, their vehicle sank to the icy depths, along with seventy packages of their sponsor's muesli.

Klaus Viedebantt

waders – come yearly to brood in the lake-strewn Arctic. Some 280 bird species have already been observed here. Following is a list of the important animal species of the north:

Bison. The *wood buffalo*, which is a sub-species of the North American bison (buffalo), has lived in the region south and west of Great Slave Lake since prehistoric times. A grown male can reach a shoulder height of 1.80 meters (6 feet) and a weight of up to 900 kilograms (2,000 pounds). The buffalo can some-times be seen on the edge of the Mackenzie Highway near Fort Providence: some 1,000 bison live here deep in the woods. An additional herd of some 3,000 head – a 1925 hybridization, however, with the prairie bison – lives in Wood Buffalo National Park (on the border with Alberta) on Slave River.

Caribou. The North American reindeer, once an important source of food for the Inuit and the Dene, populates the north of the continent with four sub-species. The best known and most widespread is the *tundra caribou* (barren ground caribou), which reaches a shoulder height of 1.10 meters (3.5 feet), and which can weigh more than 100 kilograms (220 pounds). Five large herds with up to 200,000 head are known; these animals usually spend the summer in the tundra, moving in the winter towards the protec-tive woods further south. Both males and females have antlers, which are shed each autumn.

Grizzly and Black Bears. The Canadian grizzlies of the tundra *(ursus arctos borribilis)* do not grow nearly as large and heavy as the famous salmon-catching grizzlies of Alaska: 250 kilos (550 pounds)

is the limit. In the sparse tundra, they feed on roots, grasses, berries and lem-mings. They kill larger animals such as caribou or muskoxen only if a good opportunity arises. The smaller black bears, incidentally, are only found in the wooded regions to the south. It is a very strong – and wise – recommendation that people keep their distance from bears of any species.

Moose. The moose, with its wide, project-ing antlers, is the world's largest deer species. The moose has a shoulder height of up to 2 meters (6.5 feet), and can weigh as much as 850 kilos (1,870 pounds). Moose live in Canada only in the wooded regions in the southern and western parts of the Northwest Territories and in the Yukon. They can often be observed on the flat swampy lakes on the edge of the highways – browsing, for

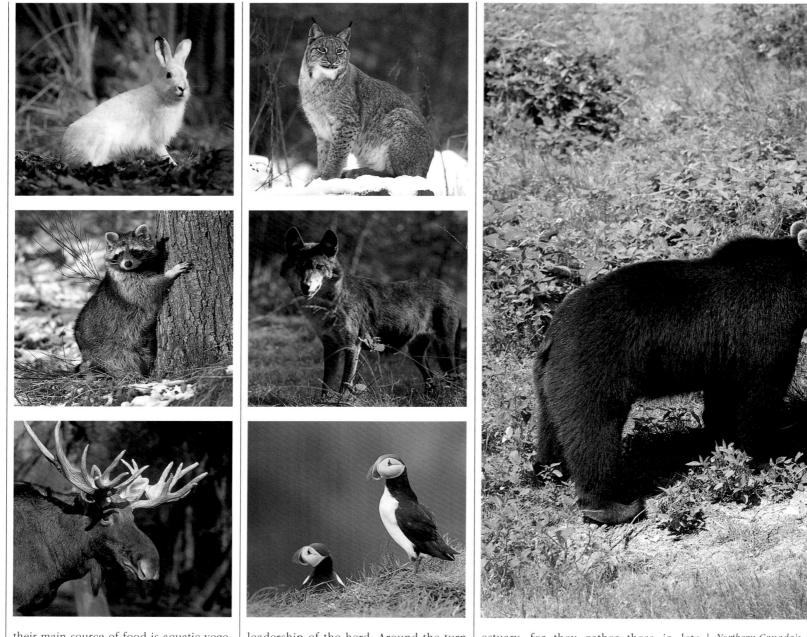

their main source of food is aquatic vegetation and birch and aspen shoots.

Muskox. Despite its name, the *ovis moschatus*, originally from Siberia, is not a species of cattle; indeed, it is much more closely related to the goat and the sheep. Because of its extremely fine, warm wool, the muskox is eminently equipped for surviving the cold. Its main distribution area is the Arctic islands and the tundra north of Great Bear Lake, where the animals live in herds of between 10 and 60 members. The main source of food for these 300-kilo (660-pound) animals is dwarf willows and tundra grasses. In August, the young bulls fight with the dominant bull for the leadership of the herd. Around the turn of the century, the muskox had almost become extinct, but after decades of strict conservation, there are some 50,000 animals today.

Polar Bears. The *ursus maritimus* is the undisputed king of the Arctic as well as the symbol of the Northwest Territories, where his likeness can be found on car license plates. Some 12,000 to 13,000 polar bears live in the Canadian north on the drift ice and pack ice around the islands and along the mainland coast, but their territory reaches to the banks of Hudson Bay far to the south. They are a particularly common sight – and a popular tourist attraction – at Churchill River estuary, for they gather there in late autumn, waiting for the bay to freeze.

Male polar bears can weigh as much as 500 kilograms (1,100 pounds), while female polar bears weigh up to 300 kilograms (660 pounds). Their main source of food is seals, which the bears usually kill when the seals emerge from their breathing holes. They also pursue birds, walruses and even beluga whales. As they do not have any natural enemies and are very curious, they are also completely fearless of man – which is why the guide must always carry a gun on trips through the north!

Seals. Seven seal species live in the north Atlantic and Arctic waters. Among them is

Northern Canada's animal world is diverse: snow hare (top left); lynx (top right); raccoon (center left); timber wolf (center right); moose (bottom left); and puffins (bottom right).

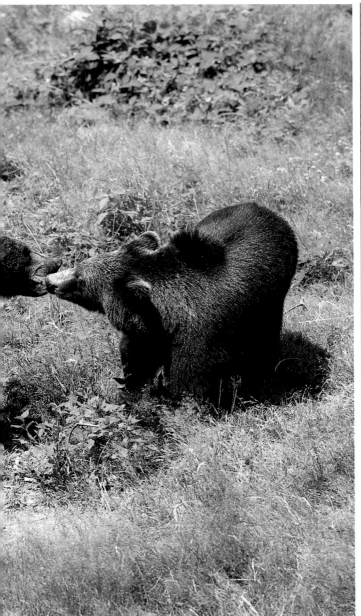

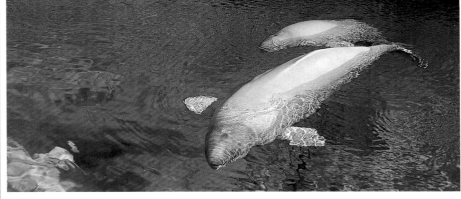

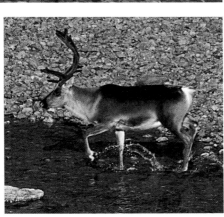

Brown bears are dexterous salmon hunters (large photograph); harp seals (top right); walrus (far right); beluga whales (center); loon (bottom left); and caribou (bottom right).

the most important, the ringed seal, of which there are some two million individuals in Baffin Bay and the north Atlantic. For thousands of years these northern sea mammals have been an important quarry for the Inuit, who use the animals' skin and flesh. Most of the infamous seal clubbings, in which hundreds of thousands of newborn croakers were killed for their white fur, took place off Newfoundland and in the Gulf of St. Lawrence. Following massive protests of nature conservationists, seal hunting in the north as well was brought to an almost complete standstill.

Walrus. The often mythologically embellished walruses of early seafaring stories are the largest seal species of the Canadian Arctic. A grown male weighs up to 1,400 kilos (3,000 pounds) and grows to four meters (13 feet). The females "only" weigh up to 900 kilograms (1,980 pounds). Walruses live in groups of several hundred animals, mainly on the edge of pack ice in the eastern Arctic and in Hudson Bay.

Whales. There are numerous whale species in the north Atlantic and in Baffin Bay, but only four species in the Arctic waters: the typical black and white marked *killer whale;* the 20-meter (65-foot) *Greenland whale;* the *narwhal,* known for its long horn (actually a tooth), many meters in length; and, finally, the most widely distributed species, the *beluga whale.*

Whalers used to call the beluga whale the "canary bird of the north," for the cheerful sound of white whales chirping often penetrated the planks of their ships. This five-meter- (16-foot-) long, conspicuously snow-white tooth whale is the most commonly occurring species in polar waters – there are some 80,000 of them. In summer they gather in large pods, often several thousand strong, in the estuaries of Hudson Bay River and along the Arctic Ocean coast.

Wolf. While the wolf in the USA and southern Canada is almost extinct, there are still some healthy, strong packs in the Northwest Territories tundra and even on the Arctic islands. Wolves grow to be the

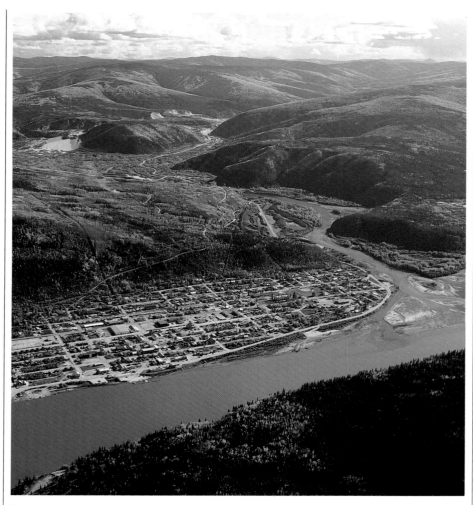

Dawson today on the banks of the Yukon and Klondike Rivers, with the gold fields in the background.

size of Alsatian dogs, and live in packs numbering on average four to seven animals. They generally hunt very young or very old quarry. Depending on the region, this can be caribou, bison, moose or muskoxen. If there are no large animals available, they will pursue Arctic hare, lemming, beaver or even fish. During a journey to the north, the traveler will very rarely see the extremely shy wolves.

PLACES, LANDSCAPES AND NATIONAL PARKS WORTH SEEING

ARCTIC BAY/NANISIVIK ①. The two settlements (some 900 inhabitants altogether) lie roughly 20 kilometers (12.5 miles) apart, on the northern tip of Baffin Island, and they are at the junction of the only road in the northeastern Arctic. Arctic Bay was created around 1920 as a trading post, Nanisivik as a mining settlement only in 1974. Various minerals are mined here.

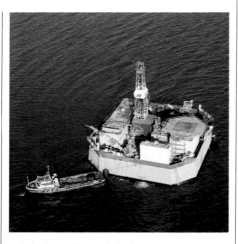

Oil platform off Herschel Island. Canada is a major exporter of petroleum and natural gas.

ARVIAT ②. Further details concerning the region's history can be garnered in the *Inuit Cultural Center*, where the visitor can watch Inuit artists at work. In summer, over 400,000 snow geese nest in the *McConnell River Bird Sanctuary*.

AUYUITTUQ NATIONAL PARK ③. An elemental wilderness, which certainly justifies its name, "the land that never melts." Park tours and expeditions begin in *Pangnirtung*, leading over the *Pangnirtung Pass* to *Broughton Island*, the east coast offshore island. Another possibility is a boat excursion to the old whaling station in *Kekerten Historic Park*.

BAKER LAKE ④. Baker Lake, the only inland Inuit settlement, is on the lake of the same name in the Keewatin district west of Hudson Bay. It is the principal establishment of the Caribou Inuit, who have lived here for about 1,000 years. Hunting and fishing are still their most important means of livelihood. Recently, the artists of Baker Lake have acquired a good reputation with their engravings and sculptures. Muskoxen and caribou are be observed on the tundra.

CAPE DORSET ⑤. This village, located on an island off the hilly southwest coast of Baffin Island, counts just 1,000 inhabitants. The *Dorset Culture* was named for archeological excavations found near the village, which flourished in the Arctic between 1000 B. C. and A. D. 1000. Cape Dorset also represents the flourishing of Inuit art; here, as early as the 1950s, the first artists' co-op was founded. Expositions and numerous Inuit studios provide an overview of their artistic creations.

CHURCHILL ⑥. The city of 1,000 souls in the province of Manitoba, on the southwest bank of Hudson Bay, is the oldest permanent settlement in the north. As early as 1731, Hudson's Bay Co. fur traders began building a strong stone fortress, which can still be visited today. With the building of a railroad line, Churchill became a port from which wheat from the Canadian prairies is shipped. Today, the city is mainly known for its polar bears – literally hundreds of the white giants gather in late autumn at the estuary of Churchill River; they can be observed from special high-wheeled tundra vehicles. In summer, Churchill is a mecca for bird enthusiasts, and beluga whales can often be seen at the estuary.

DAWSON CITY ⑦. The "San Francisco of the North," on the eastern bank of the Yukon River at the mouth of the Klondike River, was created practically overnight – in

A hike through the Arctic is no stroll, and a tour through the valley of Weasel River is not just pleasure. Only 350 people a year visit Auyuittuq National Park, and they all have great plans, as the rangers report. But many, they add, overestimate themselves and the wilderness. They would be back in two days. There is no dearth of reasons for tours to be broken off, ranging from inhumanely heavy rucksacks on the arduous path, to the weather which does not care to be called summer. "This is nature in the raw," a hiker wrote in the visitors' book.

We experienced our three days in this manner during the endless march to Summit Lake, the highest point of Aksayook Pass: balancing on the scree of the moraine, sometimes needing hours to cross the dozens of branching glacier streams, or finding only a steel cable stretched over the raging river where the map had promised a bridge.

Auyuittuq National Park is approximately 21,500 square kilometers (8,400 square

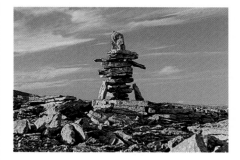

Inukshuks, Inuit signposts.

miles) in size. But there is only one path, the 97-kilometer- (61-mile-) long Aksayook Pass, traveled by the Inuit with their dog teams in the mists of time. The pass is marked with inukshuks, little gnomes of stacked stone. The Inuit claim that some inukshuks have magical powers; they certainly gave us courage. A few more meters won, they seemed to whisper to us, not much more to go now! Obviously we would have found our way along the path without them, as it follows the gully which massive glaciers had carved into the rocks. For one week we lived as prisoners in this hollow, locked in between steep towering granite walls – and locked in by a lowering sky, which caused the landscape to disappear in snow and fog as soon as we followed the glacier tongues and moraine into the lateral valleys.

At any rate, we tented under Mount Thor, the largest granite wall in the world –

IN AUYUITTUQ NATIONAL PARK

Extremely tough trekking through the incomparable primeval landscape of Baffin Island north of the Arctic Circle requires good physical condition and wilderness experience.

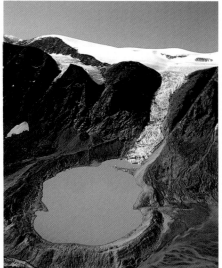

Natural forces on Baffin Island: a glacier slides through the rocky cliffs.

one and a half kilometers (0.94 miles) high and one and a half kilometers (0.94 miles) wide. We experienced the moment in which the setting sun, reflected on the snowcapped tip of the Breidablik, turned the spiral-shaped cliffs into a rosebud. But we did not really experience the drama of the country until the seventh day, when the sky cleared and we escaped the valley for the first time. From the summit of Mount Tyr we viewed a churned-up ocean of snow and granite. As far as the eye can see, all the way up to the horizon, extend precipitous summits and projecting glaciers, a magical land where the sky glows in the gleaming white of the Penny Ice Cap, both the point of departure and last remains of the great ice age. Auyuittuq means "the land which never melts." It is one of the most impressive landscapes in the world. But it should not be feared that it will become a holiday destination. How could it, with the season limited to July and August, when hurricanes sweep over the land for the rest of the year, and the temperature sinks lower than 40 degrees below zero Celsius (– 40 degrees Fahrenheit), and Arctic darkness reigns throughout the winter? For these reasons, therefore, visitors even in the far distant future will have to content themselves with tiny protective huts, with a couple of toilet shacks, and with two or three planks or ropes where it would be difficult to cross the river. More conveniences are not planned; on the contrary, the National Park Service is now considering quotas for visitors.

We were the last group to leave the park this summer. It was high time. On the last evening, puffs of fog like spirits from the sea moved into the fjord. Just a few messengers at first, gently settling on the moraine, and then a whole battalion. Like a curtain, the fog drew across the land. The next morning, snow had fallen. At the beginning of September, winter had come. *Freddy Langer*

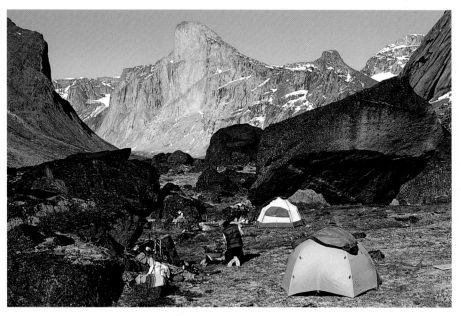

Camp of the persevering in front of the stone backdrop of Mount Thor in Auyuittuq National Park.

1896 when gold was discovered in streams in the area. Three years later, some 30,000 adventurers rushed here. Today, some 2,000 people live here. The entire city has been declared a historical district. Particularly worth seeing: the *Palace Grand Theatre*, which in summer revives the gold rush atmosphere in the "Gaslight Follies" show; *Jack London's Cabin* and the old paddle-wheel steamer *Keno;* the *Dawson City Museum* docu-

A city made of model kits: Inuvik in the Mackenzie Delta, created in 1955.

ments the past and shows silent movies of pioneer days. Incidentally, gold is still prospected in the surrounding valleys.

ELLESMERE ISLAND ⑧. With approximately 200,000 square kilometers (78,125 square miles) of surface, Canada's northernmost island is also the second largest. *Cape Columbia*, surrounded by permanent pack ice, is located on the northern tip of Ellesmere on the 83rd degree latitude – just 780 kilometers (490 miles) from the North Pole. Massive, barren mountain ranges, culminating in 2,600-meter (8,450-foot) *Mt. Barbeau*, and great glacier fields predominate on the island. In the northeast, however, around *Lake Hazen*, a "thermal oasis" with amazingly warm, frost-free summers and luxuriant tundra vegetation was created through favorable reflection of the sun's rays. Small herds of muskoxen and Peary caribou, Arctic hare, wolves, foxes and more than 30 bird species live in the 40,000-square-kilo-

meter (15,625-square-mile) Ellesmere Island National Park Reserve in the island's north.

GREAT BEAR LAKE ⑨. Just on the Arctic Circle, there stretches the huge water surface of Great Bear Lake, which breaks up into numerous bays and side channels. The lake is 320 kilometers (200 miles) long and in places 175 kilometers (110 miles) wide. Canada's largest lake –

Iqaluit on Baffin Island, mentioned as early as 1576, became a modern supply center.

31,000 square kilometers (12,110 square miles) – is also the eighth largest in the world. Only the southern and western banks are still wooded; in the north extends the tundra, home to a wealth of animal species – grizzlies, caribou and marten. The only settlement on the bank of the lake rich in fish, the Dene village of *Fort Franklin*, lies in the extreme west, near the outflow of *Great Bear River*.

GREAT SLAVE LAKE ⑩. The name "Slave" is quite misleading. The tenth-largest lake in the world was named by fur trader and discoverer Samuel Hearne for the Slavey Indians living here. This lake, remnant of the ice age, is over 600 meters (1,950 feet) deep, and has a surface area of 28,750 square kilometers (11,230 square miles). It is the second-largest lake in Canada after Great Bear Lake. The banks on the western half of the lake, where the capital of Yellowknife is situated, are relatively well connected by gravel highways. Other smaller towns are situated here: *Rae-Edzo, Fort Resolution, Hay River* and, on the outflow of the Mackenzie River, *Fort Providence*. The eastern arm of Great Slave Lake, dotted with islands, on the other hand, is still mainly undeveloped, and is to be declared a national park in the next few years.

GRISE FJORD ⑪. Canada's northernmost settlement, surrounded by a fjord-furrowed coast and high towering snow-capped peaks, lies on the southern tip of *Ellesmere Island*, nearly on the 77th parallel. Some 100 Inuit from the south live here – but not very happily – in a socially problematic environment. They were settled here in 1953 as the result of an official decision to strengthen Canada's sovereignty in the Arctic.

INUVIK ⑫. The modern pile buildings of the settlement, built as an oil city between 1955 and 1961, are as colorful as Easter eggs. Some 3,000 people live here – Inuit, Dene and whites – on the eastern edge of the mighty Mackenzie Delta, and give the town's name, "Place of the People," full honor. Inuvik is the northernmost town attainable by road in Canada. The 745-kilometer- (465-mile-) long *Dempster Highway* connects Inuvik with Dawson City in the Yukon Territory. In the town itself, the igloo-shaped Catholic Church is worth seeing. There are air tours to the trapping town *Aklavik* in the 80-kilometer- (50-mile-) wide river delta, northwest to the old whaling station *Herschel Island*, and the settlement of *Tuktoyaktuk* on the Arctic coast in the tundra of the northern Yukon Territory.

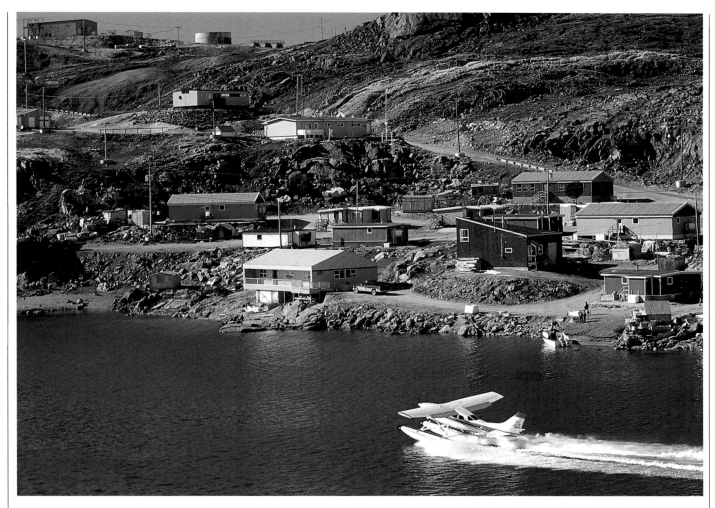

An amphibious plane, typical of the Canadian north, on the North Bay "runway" off Lake Harbour on Baffin Island.

IQALUIT ⑬. This little city in the south of Baffin Island, the administrative center for the eastern Arctic, has a population of over 3,000 and a modern infrastructure. Sir Martin Frobisher discovered the bay, later named after him, in 1576, when he happened upon an Inuit fishing village. Fur traders and whalers soon followed. The modern impetus did not occur, however, until the Second World War, when the US military established an air base here. Since then, Iqaluit has developed into the region's air traffic junction. In the town, a call at the *Visitors' Center* is worthwhile. A 20-minute boat trip leads to *Qaummaarviit Historic Park*, which preserves an over 2,000-year-old Inuit settlement area with winter quarters.

KLUANE NATIONAL PARK ⑭. This protected park, created in 1976, contains some 22,000 square kilometers (8,590 square miles) of glacial and high mountain wilderness. Here in the St. Elias Moun-

tains are found the most massive ice fields outside the polar region. This park contains *Mt. Logan*, Canada's highest mountain, 5,959 meters (19,400 feet) high. Although permanent ice reigns in the peak regions, good wilderness hikes are

Bathing enthusiasts enjoy the hot springs in Nahanni National Park.

possible in the northern promontories. A trip by rubber dinghy on the *Alsek* or *Donjek Rivers* merits a trial. Departure point for tours is *Haines Junction* on the Alaska Highway, where an excellent slide show in the park's information center portrays the unique mountain world.

NAHANNI NATIONAL PARK ⑮. Some 5,000 square kilometers (1,950 square miles) of mountain wilderness await hikers and white water enthusiasts in the southwest of the Northwest Territories. The *South Nahanni River* rushes for 320 kilometers (200 miles) through the impressive 1,200-meter- (3,900-foot-) deep canyons of the *Mackenzie Mountains*. The high spot of every tour is the 90-meter- (292-foot-) high *Virginia Falls*. Originating in *Fort Simpson*, *Fort Liard* and *Watson* are flight excursions and canoe tours to the park, attainable only by boat or mountain paths. Hiking and wilderness camping are also available.

PAULATUK ⑯. The name of the village (200 inhabitants) south of *Darnley Bay* on the Arctic Ocean coast means "coal dust." It is aptly named, for there are coal seams in the *Melville Hills* east of the town. Paulatuk was built in 1935 around a Catholic mission, whose attractive little church is still maintained. The town's Inuit population still lives by traditional hunting and fishing, but more recently, also from arts and crafts. Inuit guides take visitors to the undulating tundra in the hinterland, where muskoxen, caribou and sometimes even polar bears can be seen.

POND INLET ⑰. This village of 800 souls on the northern tip of Baffin Island would hardly be worth mentioning were it not for the spectacular landscapes and fauna. Massive glacier streams pour from icy mountains into the sea. Walruses, beluga whales and narwhals romp in the sea-lane off the town, and in summer hundreds of thousands of aquatic birds nest on the offshore island of *Bylot Island.* The new *North Baffin National Park* is to be created here in the next few years.

RANKIN INLET ⑱. The town (1,300 inhabitants) on the west bank of Hudson Bay, the supply center for the entire Keewatin district of the central Arctic, is the starting point for tours to the smaller Inuit towns in more distant surrounding areas. Tours are available, for example, to *Coral Harbour* on Southampton Island, where great walrus herds live; to the traditional Inuit village of *Whale Cove;* and to the historical mission of *Chesterfield Inlet.*

RESOLUTE BAY ⑲. Only 200 people, mostly Inuit, live here on the southern tip of *Cornwallis Island;* yet it is the crossroads of the High Arctic and the starting point of many expeditions to the North Pole. From here, one can visit the just 300-kilometer- (190-mile) distant roving *magnetic North Pole* near *Bathurst Island.*

SACHS HARBOUR ⑳. The only settlement on *Banks Island,* it is the westernmost of the Arctic islands. Particularly impressive is the wealth of fauna: great muskox herds, polar bears, and a variety of migratory birds. Reason enough to place a large portion of the island under conservation in the planned *Aulavik National Park.* Inuit guides lead nature enthusiasts to the best observation points.

Artistically carved Indian totem pole in Whitehorse.

Indian children in Old Crow, Yukon Territory.

Poster-like Indian art: mural in Whitehorse, the capital of the Yukon.

WHITEHORSE ㉑. Today's capital of the Yukon Territory – with a population of 18,000 the largest city in the Canadian north – was created in 1898 as a place of rest for gold prospectors on their way from Alaska's Skagway Harbour to the Klondike gold fields. It was not until 1942, with the completion of the Alaska Highway, that the modern upswing came to the little city on the banks of the Yukon. Today, Whitehorse is a modern city with good hotels and restaurants, but its history since gold prospecting times has not been ignored, as a visit to the *McBride Museum,* for example, or to the restored *Yukon Paddle Wheel Steamer* SS Klondike will prove. Whitehorse is a good starting point for tours to Skagway (Alaska), to *Kluane National Park* or for a canoe tour on the Yukon to *Dawson City.*

WOOD BUFFALO NATIONAL PARK ㉒. South of Great Slave Lake lies Canada's largest national park, one-third of which is contained in the Northwest Territories. Its 45,000 square kilometers (17,600 square miles) comprise a surface area larger than Switzerland. In the mighty delta of the *Peace* and *Athabasca Rivers* stretch endless woods, lakes, swamps and great karst landforms, which, in addition to sheltering bison herds, are also home to wolves, grizzly bears and countless aquatic birds. The starting point in the region is *Fort Smith;* boat tours are proposed on Slave River on the edge of this rugged northern park.

YELLOWKNIFE ㉓. The capital of the Northwest Territories (15,000 inhabitants) lies on a bay on the northern bank of *Great Slave Lake.* As early as 1790, it was a trading post in the land of the Dene Indians, but its upswing did not occur until the discovery of gold after 1930. In 1936, the first mine was opened and increasing numbers of settlers moved in. Yellowknife was made the capital in 1967. Modern government buildings today stand in harmony next to old log cabins – the lookout point on *Pilot's Mountain* affords a good view of these buildings. *Prince of Wales Northern Heritage Center* affords an excellent glimpse of the history and culture of the north. The extensive hinterland can be discovered by boat or by plane. Recently, another boom has the town in its grip: diamonds have been found in the hard rock of the Canadian Shield!

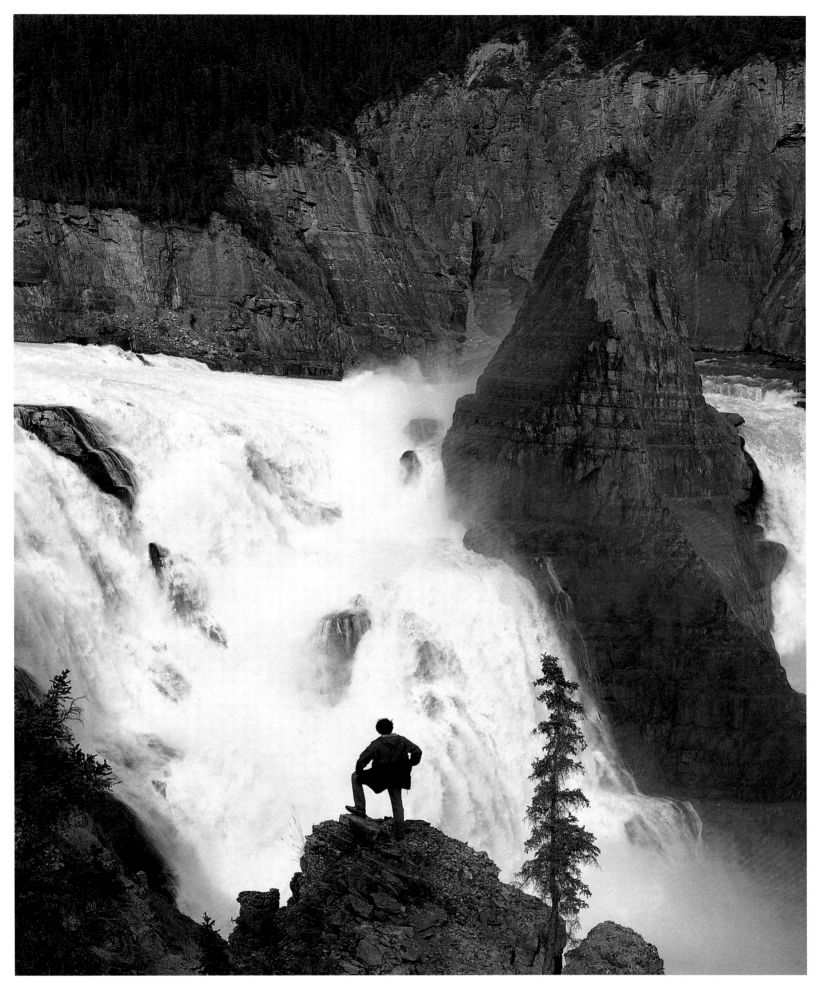

The foaming spray of Virginia Falls on the South Nahanni River in Nahanni National Park.

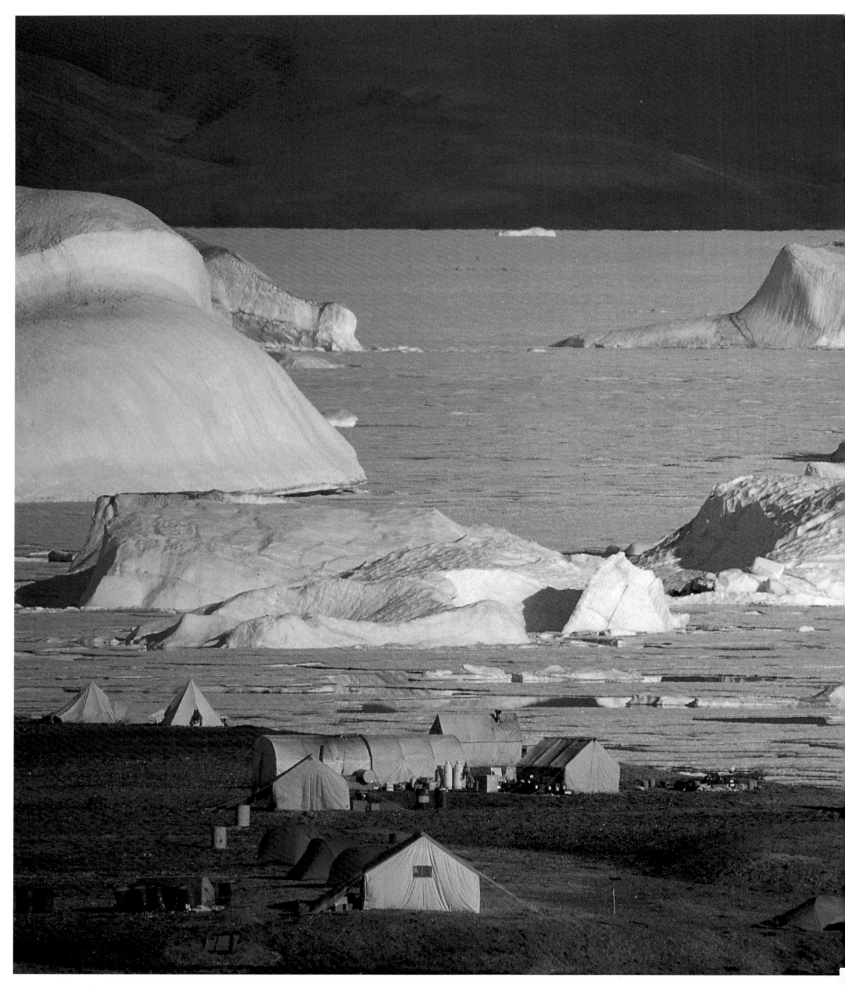

Summer camp for tough wilderness enthusiasts and geologists in front of the iceberg backdrop of Otto Fjord on Ellesmere Island.

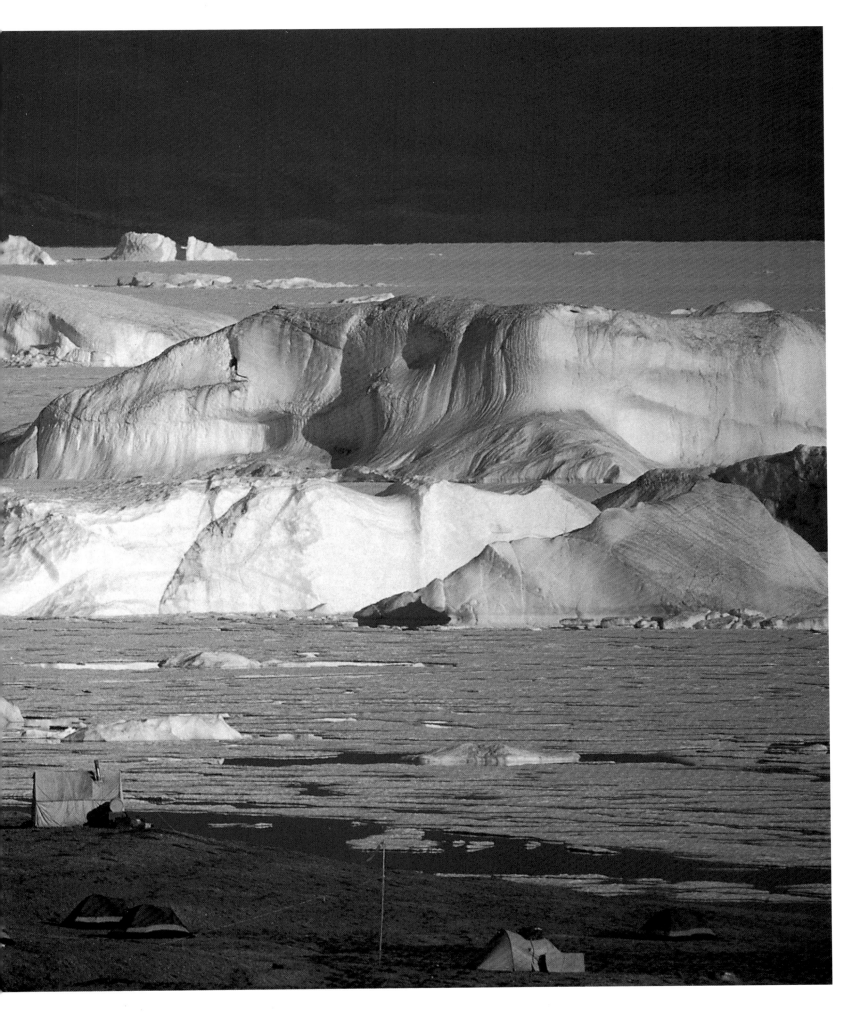

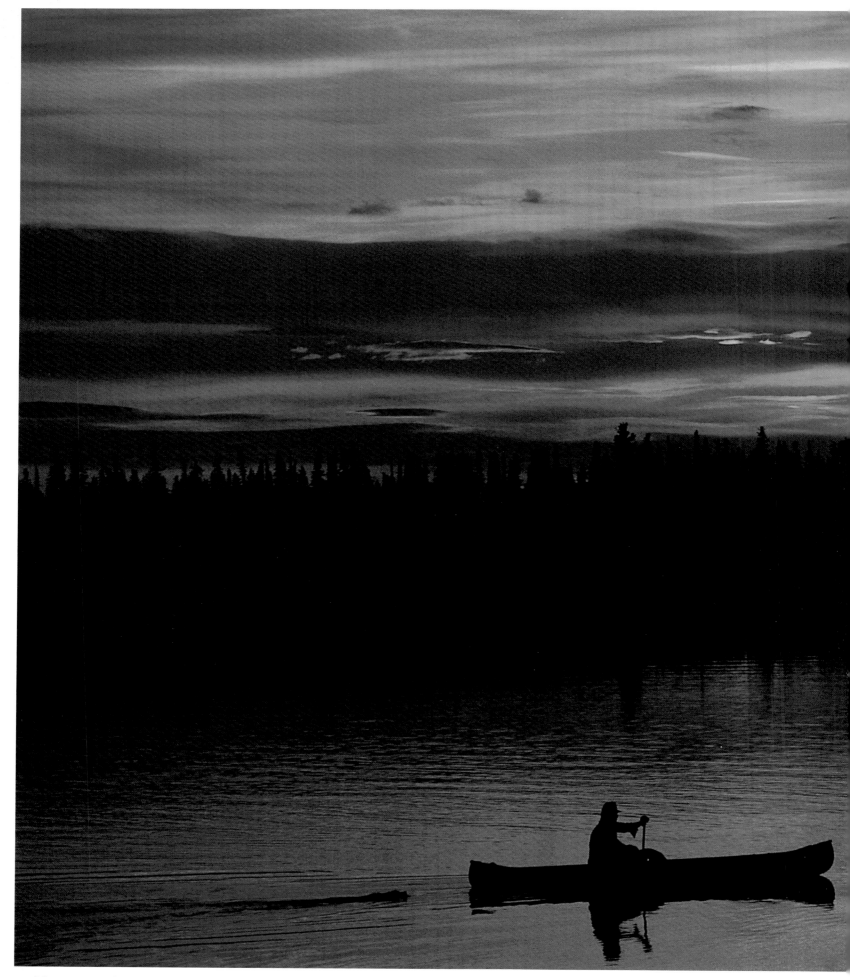

As if the Arctic sun felt it needed to make retribution – sunset on Mackenzie River near Inuvik.

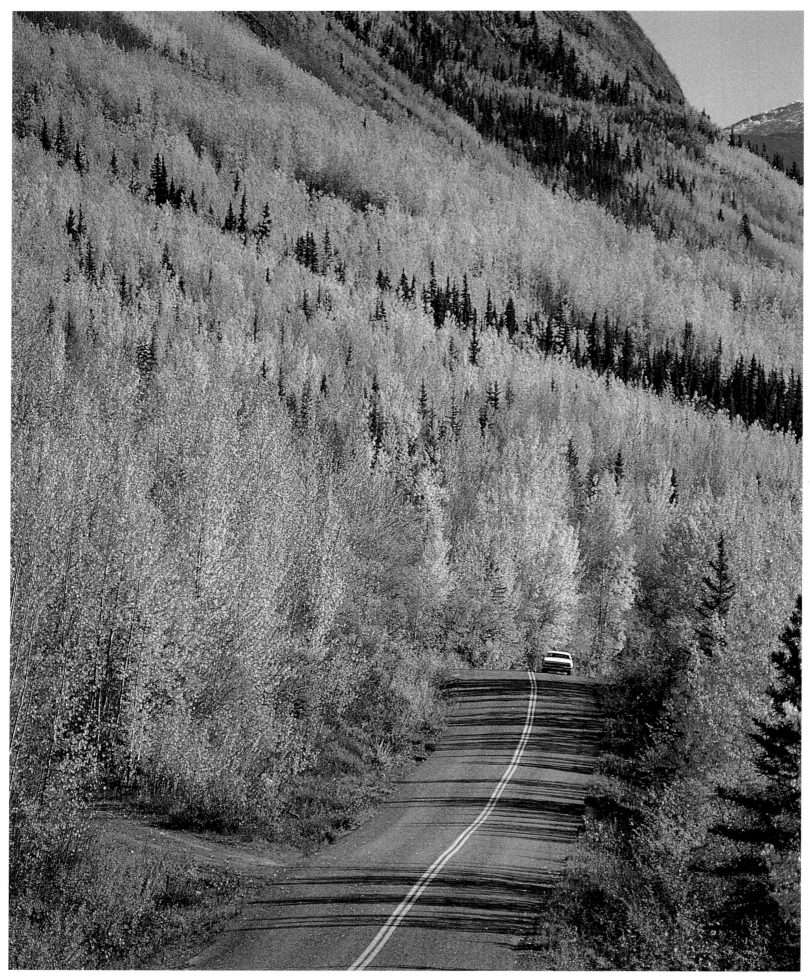

The asphalt strip of the Alaska Highway leads through the autumnal colors in the Yukon Plateau's southwest foothills.

INDEX BY KEY WORDS

Numerals in italics refer to illustrations.

Air Pollution 52
Alaska Highway 16, 47, *50*, 67, 68, 79, *86*
Amundsen, Roald 21, *21*
Arctic Bay/Nanisivik 70, 76
Auyuittuq National Park *18, 19, 22/23*, 51, 72, 76, 77, *77*
Axel Heiberg Island 63

Baffin Bay 62
Baffin Island *18, 22/23, 32*, 62, 77, 79, 80
Baker Lake 28, 76
Barrow Strait *26, 27*
Bathurst Inlet *42*
Beaufort Sea 65
Bison 37, 56, 73
Brock River Canyon *34/35*

Caboto, Giovanni 26
Camsell River *44/45*
Canadian Shield 17, 62
Cape Dorset 28, 76
Carcajou River *48/49*
Carcross *52, 53*
Caribou *38, 42*, 51, 73
Cartier, Jacques 26
Cassiar Highway *57*, 67

Chilkoot Pass 55, *55*, 71
Churchill 37, 76
Cook, James 20
Coppermine River 38, 71
Cornwallis Island 80

Davis, John 20
Davis Strait 62
Dawson City 47, *52, 53*, 55, *55*, 65, *65*, 70, 76, *76*, 78, 80

Dempster Highway *6/7*, 18, *51, 56, 58/59*, 67, 78
Dene 25, 38, 56, 60, 64, 70, 72, *80*
Discovery and Exploration 20 f., 26 f.
Dorset Culture 25, 28, 76

Ellesmere Island 25, 27, *30/31*, 47, 62, *63*, 78, *82/83*
Expeditions 20 f.

Fauna *1*, 18, *27, 37, 37*, 51, 56, *57*, 70, 72 – 76, *74, 75*, 80
Firth River *39*
Fishing 70, *70*, 71
Flora 37, *37, 43*
Franklin, John 20 f., *20, 21*, 27
Frobisher, Martin 20, 27, 79
Fur (trade) *15, 24, 25, 33*, 38, *38*, 56, 65

Gold 47, *53*, 54 f., *64*, 65, 78, 80
Great Bear Lake 78
Great Slave Lake 38, 47, *71*, 78
Grise Fjord *25*, 47, 78
Grizzlies 18, 73

Hearne, Samuel 38, 78

Horton River *43*
Hudson Bay 20, 33, 38, 62, 69
Hudson's Bay Company 20, 33, 38, 42, 76
Hunting 52, 56, 65, 72

Igloo *32, 33*
Inuit (Eskimo) *15*, 16, *16, 17*, 25 f., 28, *33*, 38, 42, *42*, 56, 60, 64, 70, 72, *72*

Inuit Arts and Crafts *17*, 28, 72, *72*
Inuvik 70, 78, *78*
Iqaluit 70, *78*, 79

Kaskawulsh Glacier *10/11*
Keewatin District 17
Keno *51*
Keno Mountain *57*
Klondike River 47, 54 f., 65
Kluane National Park *10/11*, 51, 69, 71, 79, 80

Lake Hazen 78

Mackenzie, Alexander 38
Mackenzie Highway 67
Mackenzie Mountains *50*, 63, 79
Mackenzie River *40/41*, 63, *84/85*
McClure, Robert 21
Melville Hills *34/35*, 80
Mineral Resources 54 f., 65, 80
Mining 47, *64*
Missionaries 42, 47, 80
Mount Logan 51, 63, 79
Mount Thor *19*, 77, *77*
Muskoxen *36*, 37, 51, 74

Nahanni National Park *2/3*, 47, 51, 79, *81*
National Parks 18, 47, 51, 71
Northern Lights 16, *32*, 33
North Pole 33, 73, 80
Nord West Passage 20 f., 27, 68
Northwest Territories 17, 62
Nunavut 60, 65

Ogilvie Mountains *58/59*
Otto Fjord *30/31, 82/83*

Pangnirtung *22/23*, 72, 76
Parry, Edward 20
Paulatuk 14, 16 f., *38*, 80
Peel Plateau *12/13*
Petroleum 65, *76*
Polar Bears *26, 37, 38, 74*, 76
Pond Inlet 80
Pulpit Rock *46*

Rabbitkettle Lake *2/3*
Rankin Inlet 80
Resolute Bay 73, 80
Richardson Mountain *6/7*, 63

Sachs Harbour 80
Seals 74 f.
Slim River *50*
Smoking Hills *39*
South Cape Fjord *29*
Sports *18*, 71 f., 79
St. Elias Mountains 51, *51*

Thule Culture 25, 28
Tombstone Mountain *60*
Tourism 33
Tours *18, 61*, 66, 68, 69, 70, 72, 79, 80
Tundra *12/13*, 14, 18, 37, *43*, 69

Vikings 27
Virginia Falls 79, *81*

Weasel River *18*
Wellington Channel *29*
Whales (Whaling) 16, 42, 65, 75
Whitehorse 63, *69*, 72, 80, *80*
White Pass 67, 68, *68*
Wood Buffalo National Park 37, 47, 51, 56, 80

Yellowhead Highway 17
Yellowknife 63, 65, 70, 72, 80
Yukon Territory 16, 18, 47, 54 f., 62, 69

"Frenchie," an original character of the north.

Dempster Highway is more than 750 kms (470 miles) long.

Pangnirtung on Baffin Island.

Karl Teuschl, born in 1955, has studied phonetics, American Language and Literature, and Anthropology. A freelance author and travel journalist since 1984, he has coauthored several books whose main emphasis is the United States and Canada for C. J. Bucher Publishers.

Wolfgang R. Weber, born in 1943, has collaborated on several travel guides about the United States and Canada. Regular tours on foot, by canoe, and by airplane through northern Canada have proven him to be an authority on these northern regions.

TEXT CREDITS

Jack London: The Call of the Wild. Page 210 from the ed. published in Toronto by Morang & Co. in 1903.
(This excerpt is about Buck, the sled-dog, whose story Jack London tells.)
The text on page 77 is by Freddy Langer, and has been graciously authorized in abridged version by the Frankfurter Allgemeine Zeitung, from the article of 9/29/94: "Es ist nicht mehr weit, flüstern die Inukshuks" (It is not much farther, whispered the Inukshuks).
The text on pages 20/21 and 73 was written by Klaus Viedebantt, managing editor of the Frankfurter Allgemeine Zeitung and years-long author with C. J. Bucher Publishers.
All other informative inserts were written by Karl Teuschl.

PHOTOGRAPHIC CREDITS

Archiv für Kunst und Geschichte, Berlin: pages 20, left; 20/21; 21, right; 72, right and bottom center.
Bilderdienst Süddeutscher Verlag, Munich: page 21, bottom.
IFA-Bilderteam, Düsseldorf: page 75, center.
Interfoto-Pressebild Agentur, Munich: page 20, bottom.
Inuit-Galerie, Mannheim: page 28 (3).
Kleinerts Archiv, Munich: pages 68/69, bottom; 80, top and center.
Bilderarchiv Lange, Leipzig: pages 37, top, bottom left and bottom right; 74 (6); 74/75; 75, top left, top right and bottom left; 80, bottom; reverse of the dust cover.
Yukon Archives, Whitehorse/Wolfgang R. Weber: pages 54/55 (5).
All other illustrations are by Wolfgang Weber.

The map on page 63 was drawn by Astrid Fischer-Leitl, Munich.

All the information in the edition has been carefully researched by the author and checked by the publishers for accuracy and factuality. However, there can be no liability for the correctness of the information provided herein.
The C. J. Bucher Publishing Company would like to express their appreciation to all copyright holders and publishing houses for their kind permission to reprint and reproduce photographs. Despite intensive efforts, it was not always possible to determine the whereabouts of all copyright holders. We ask that these make themselves known to the publishers.

TRAVEL ADVENTURE · WILDERNESS CANADA

Concept: Axel Schenck
Readers' Department: Dagmar Ahrens, Georg Hohenester
Translation: Sidaway Sollinger Translation Agency
Coordinator of this English language version: Cornelia Schubert
Photographic Layout: Joachim Hellmuth
Photographic Documentation: Susanne Böttcher
Graphics: Verena Fleischmann
Production: Angelika Kerscher, Armin Köhler

This English language version is published by special arrangement with Verlag C. J. Bucher, Munich, Germany
International Standard Book Number 1-55868-315-1
Library of Congress Catalog Number 96-77464
Graphic Arts Center Publishing Company
P. O. Box 10306 · Portland, Oregon 97296-0306 · 503 226 2402

© German Edition 1995 by Verlag C. J. Bucher GmbH & Co. KG, Munich